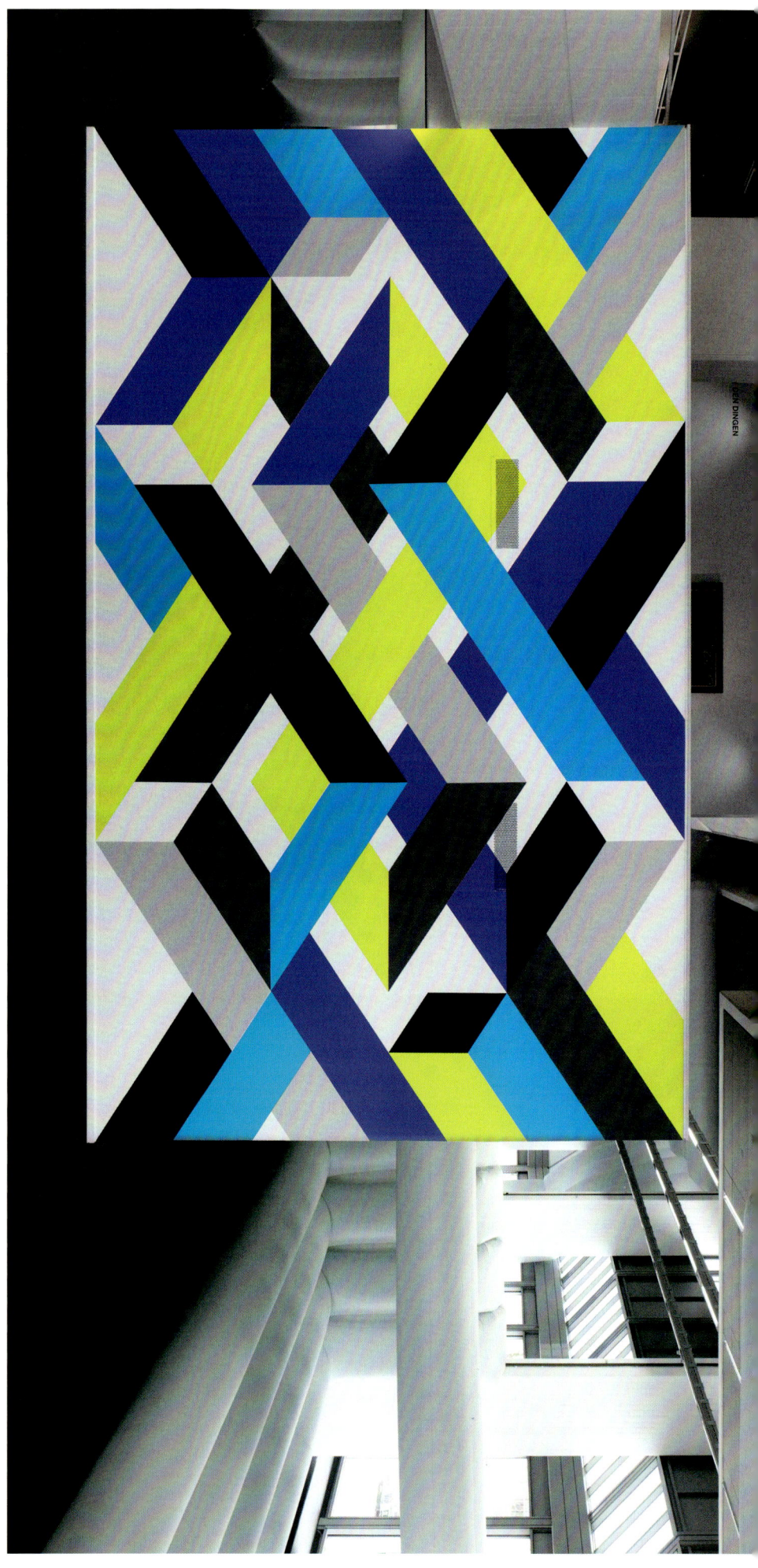

2

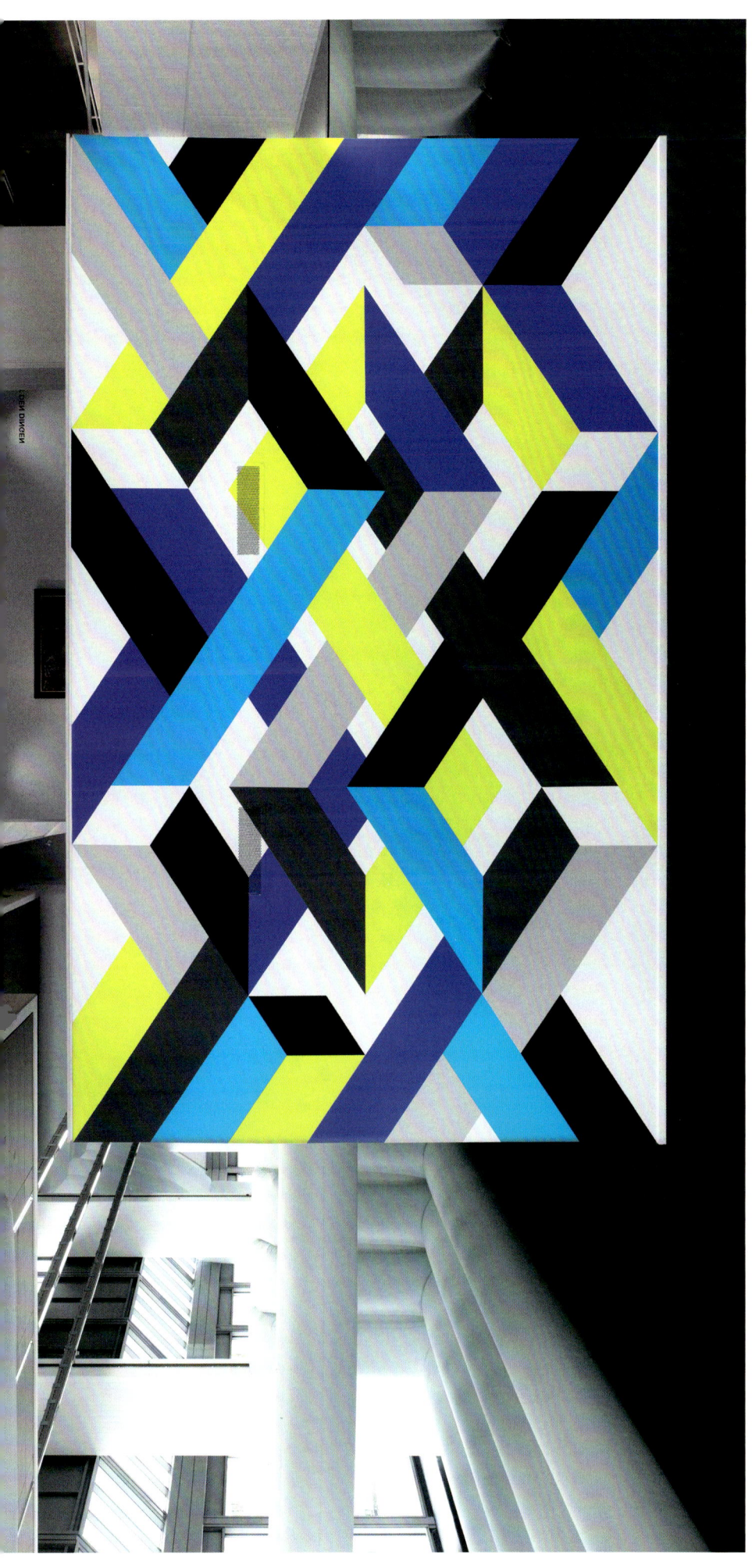

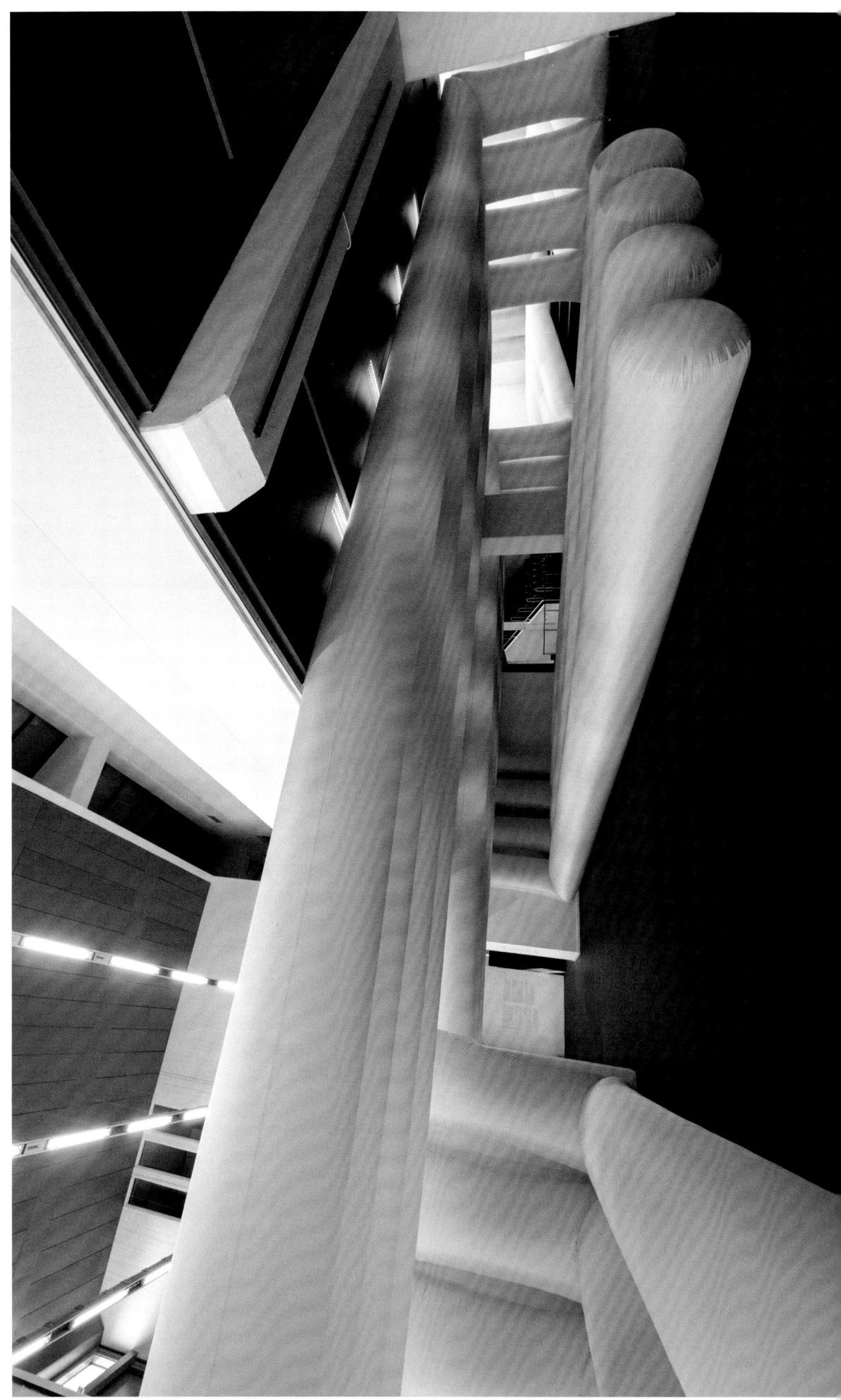

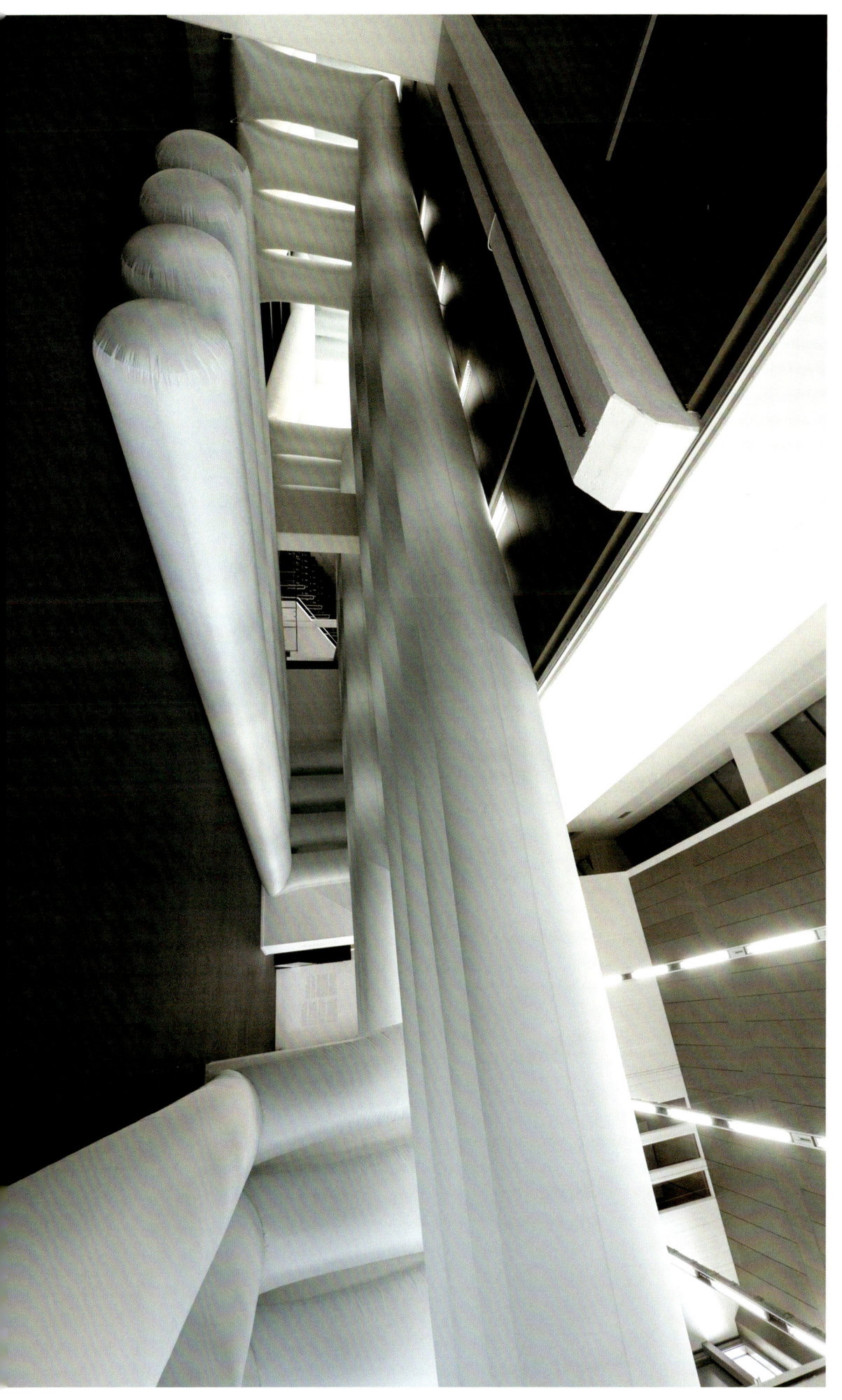

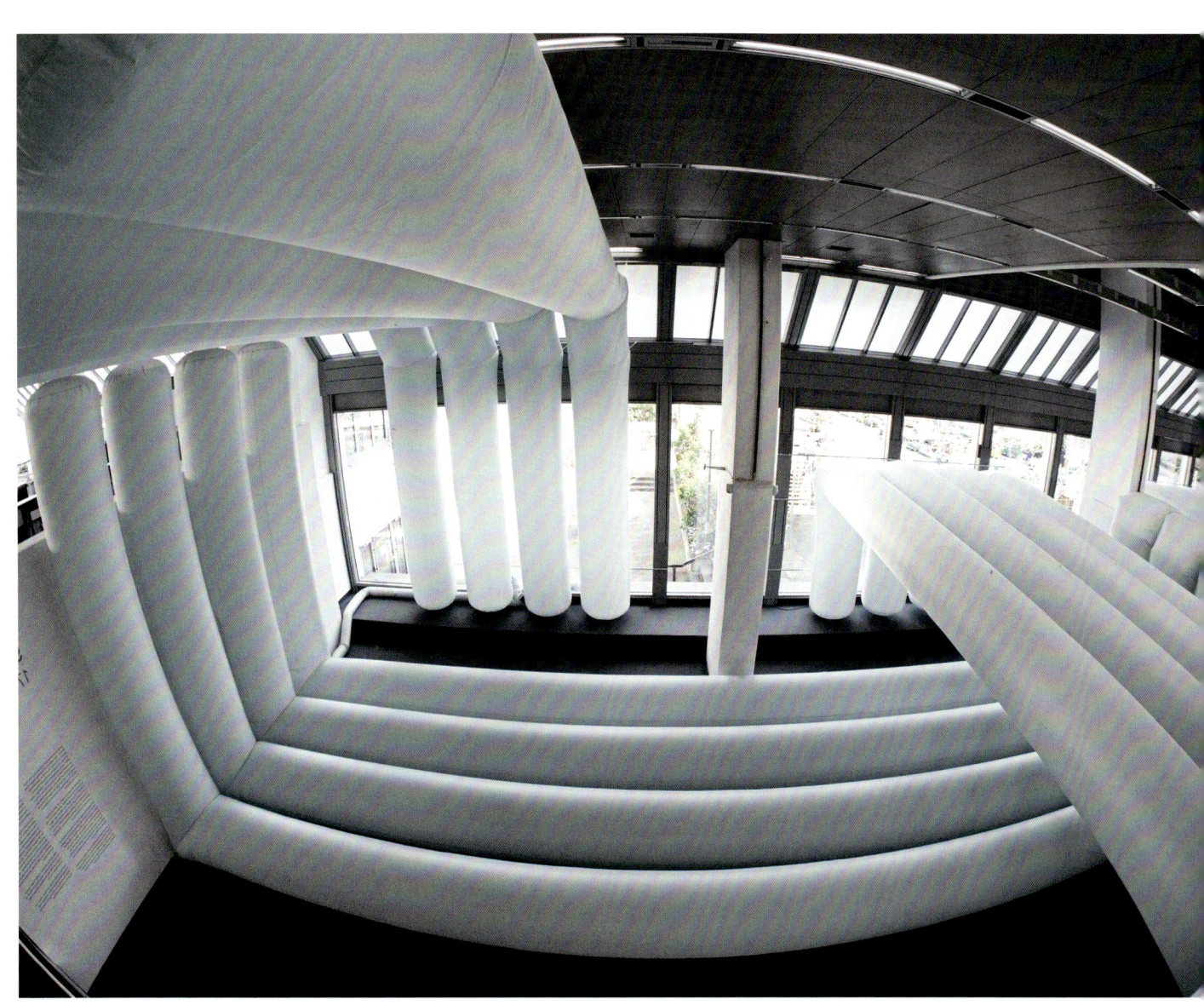

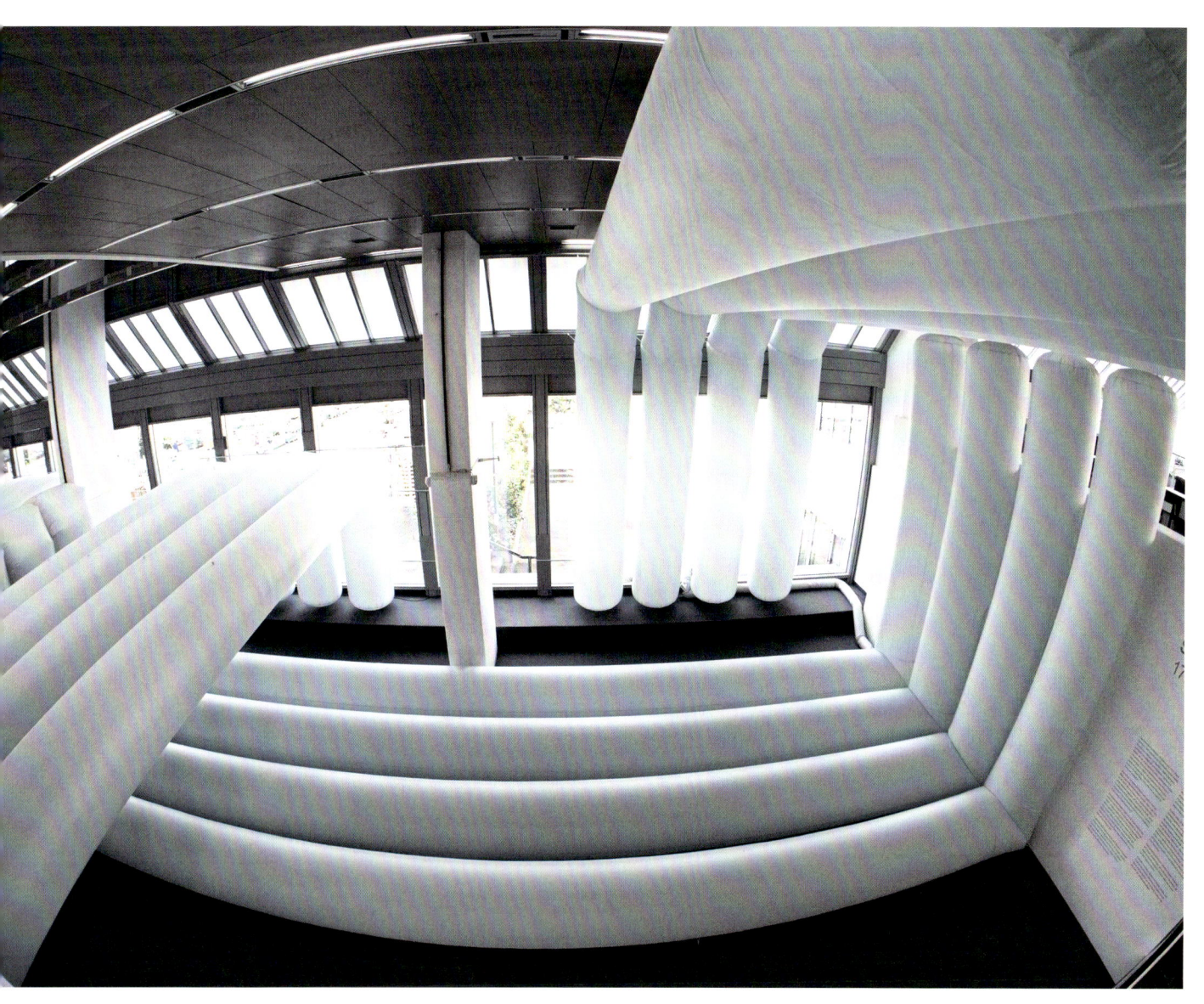

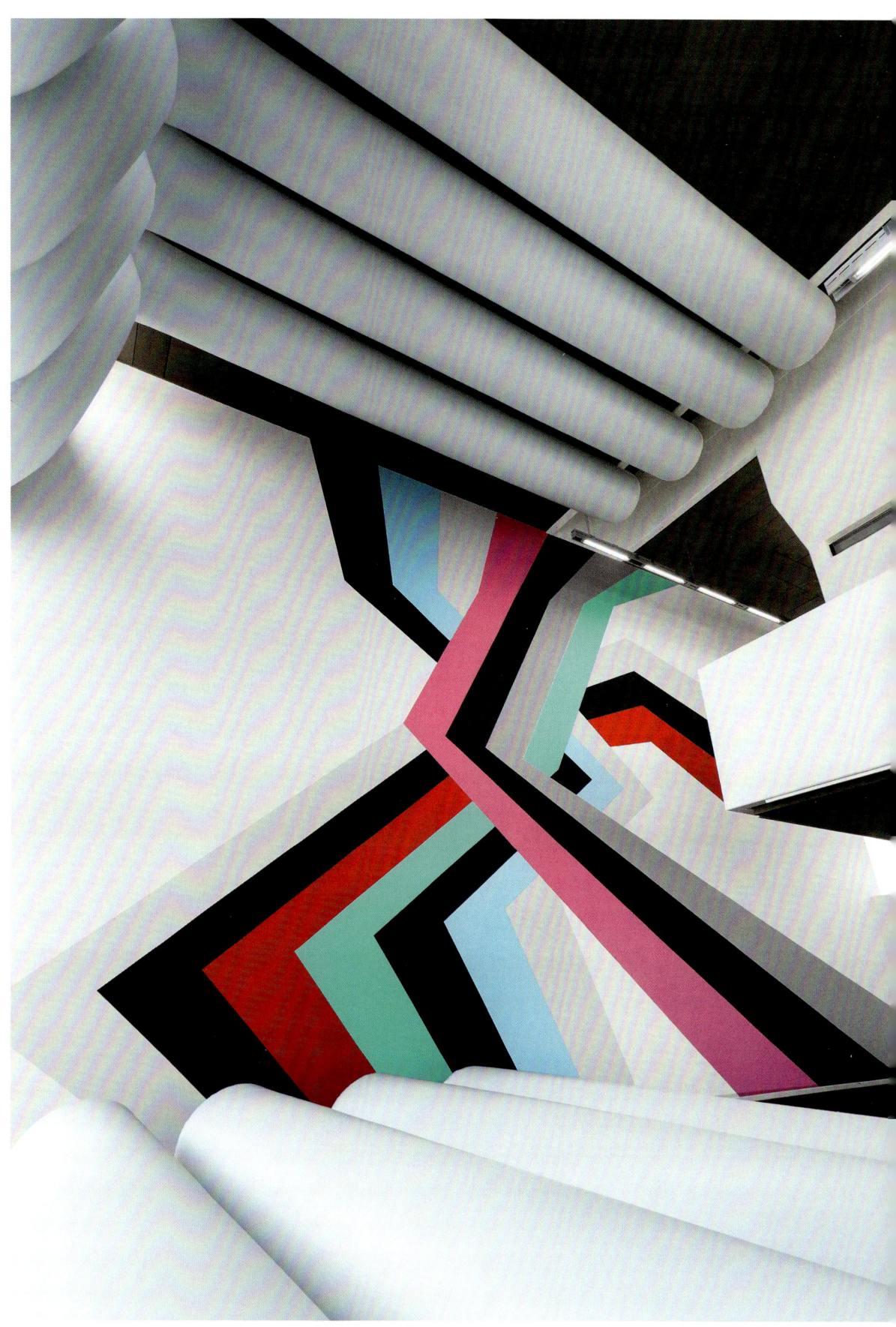

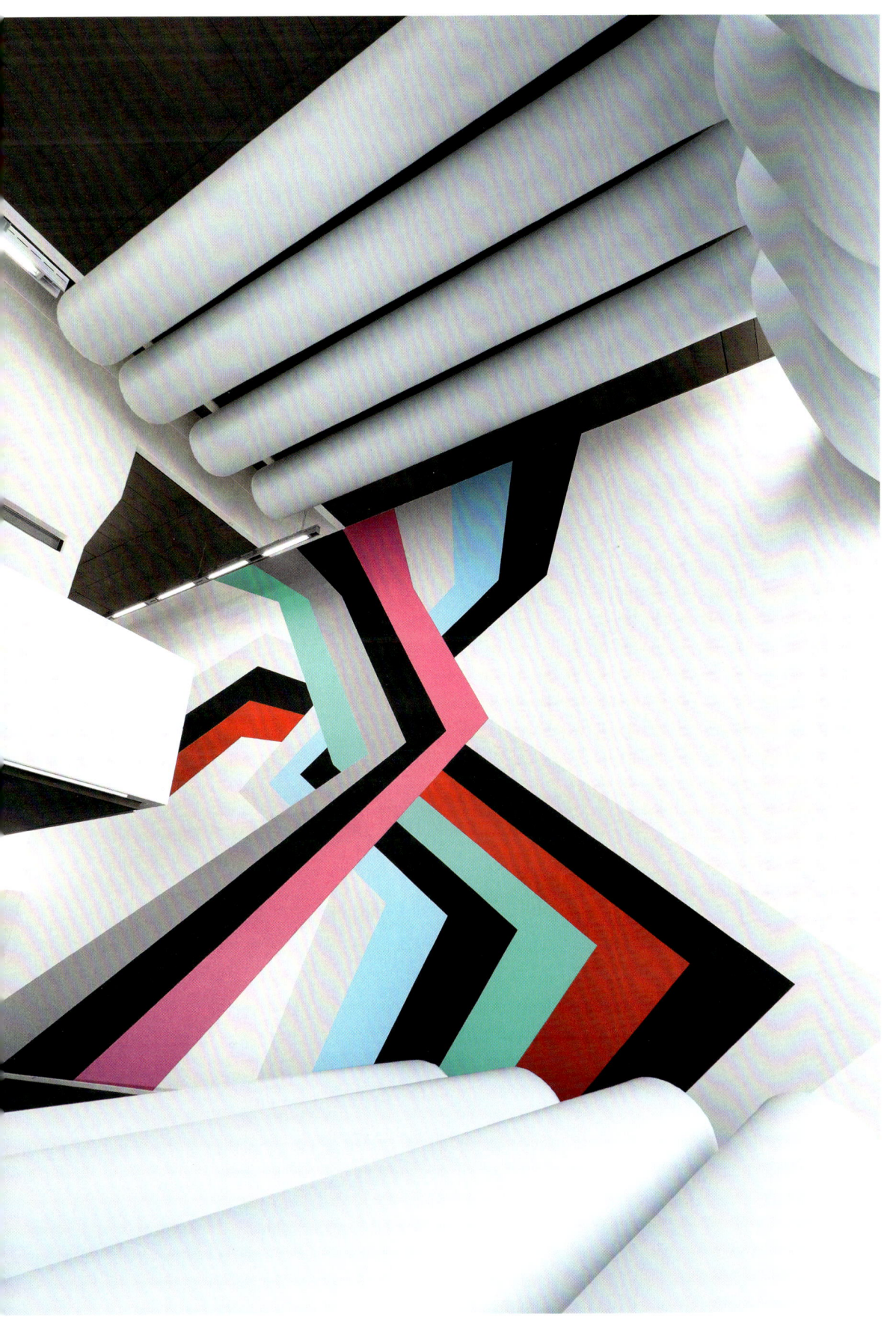

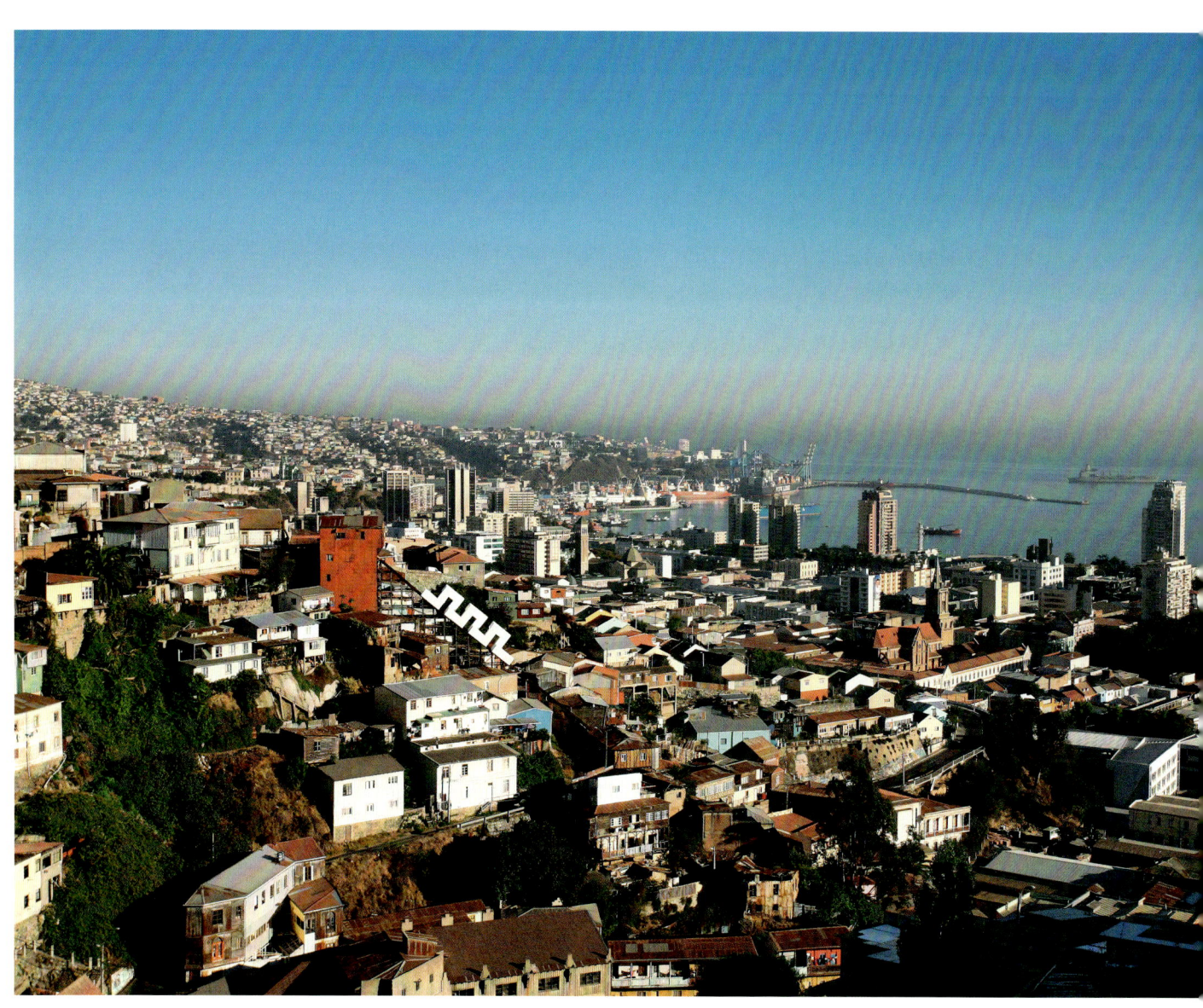

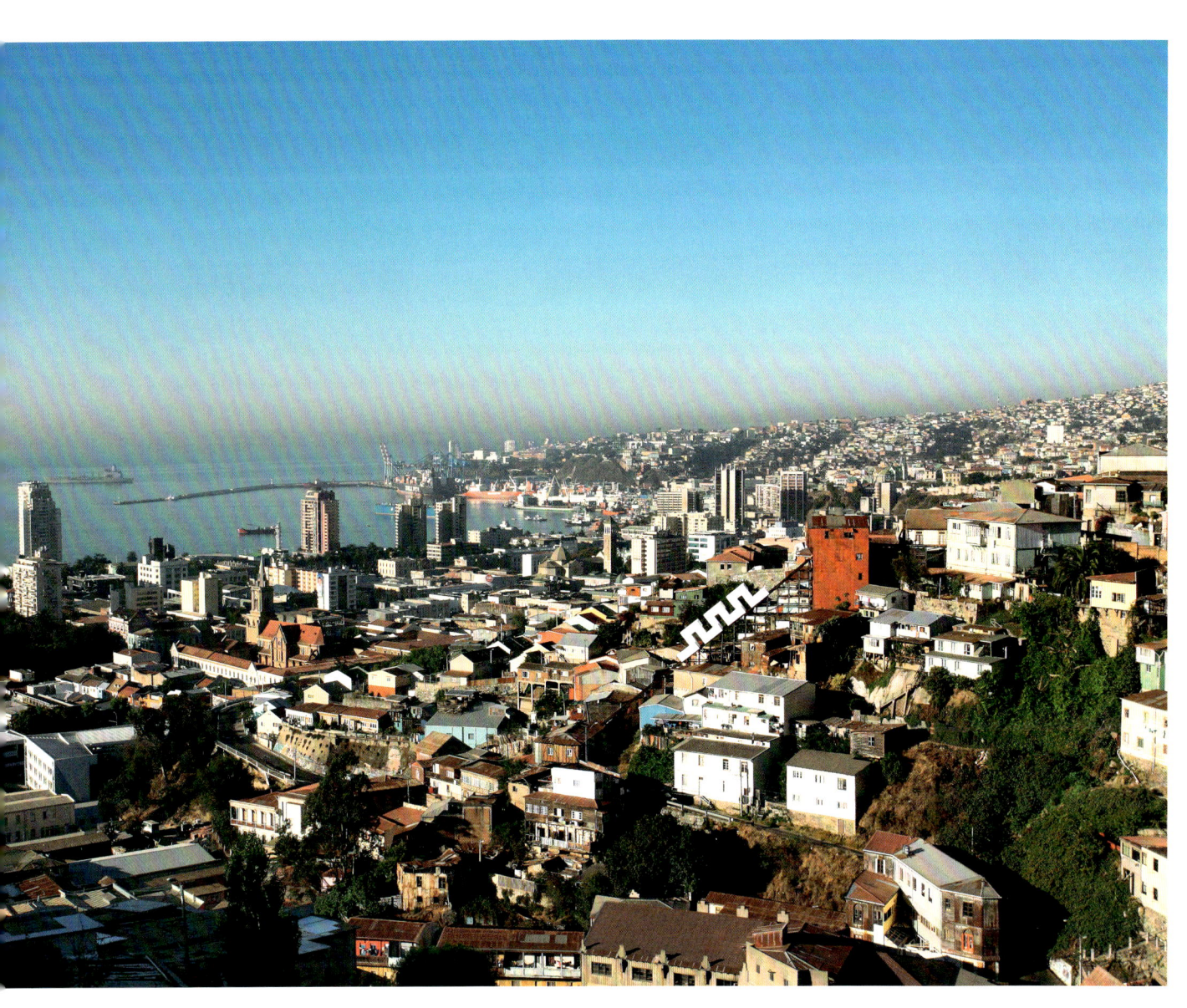

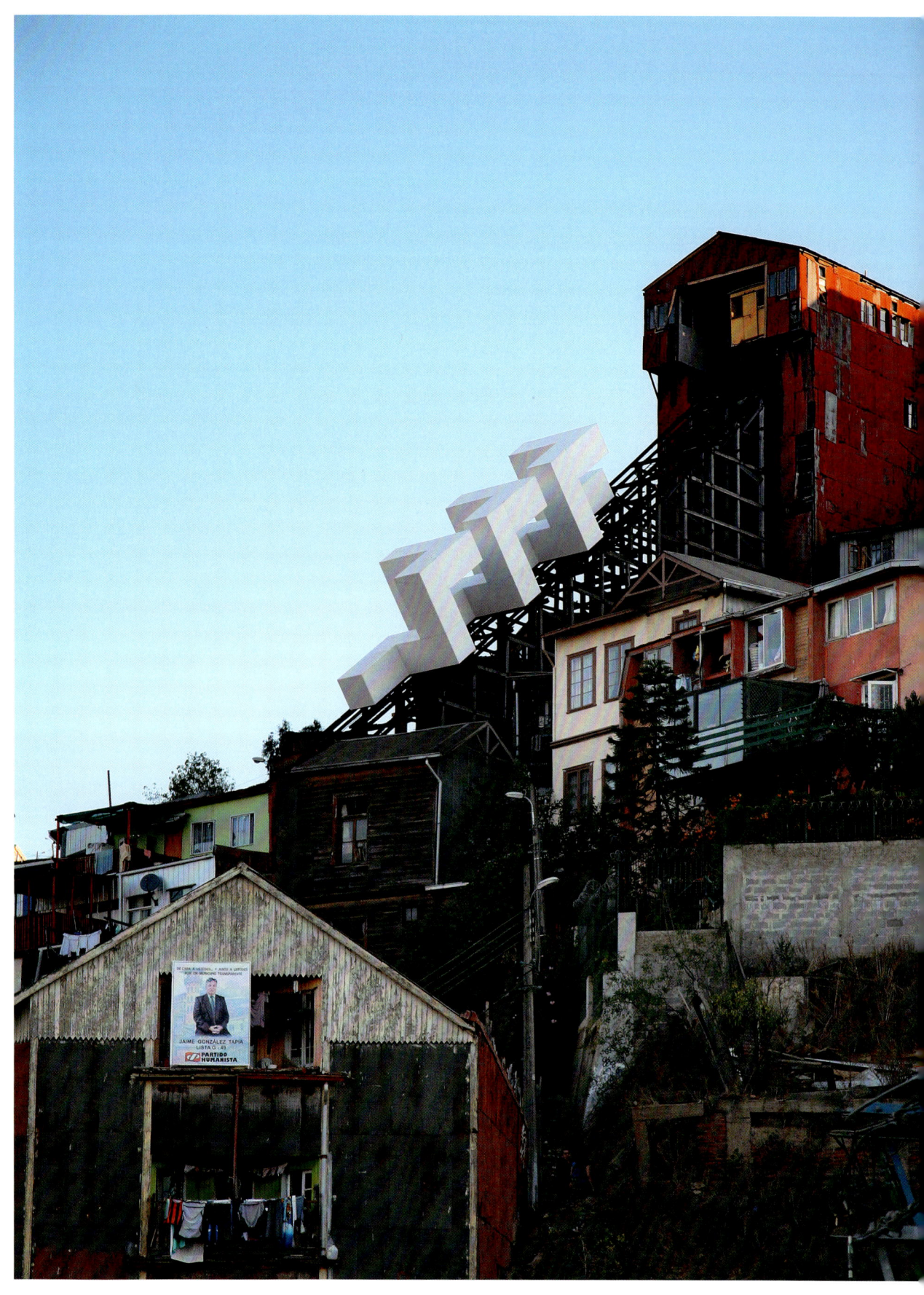

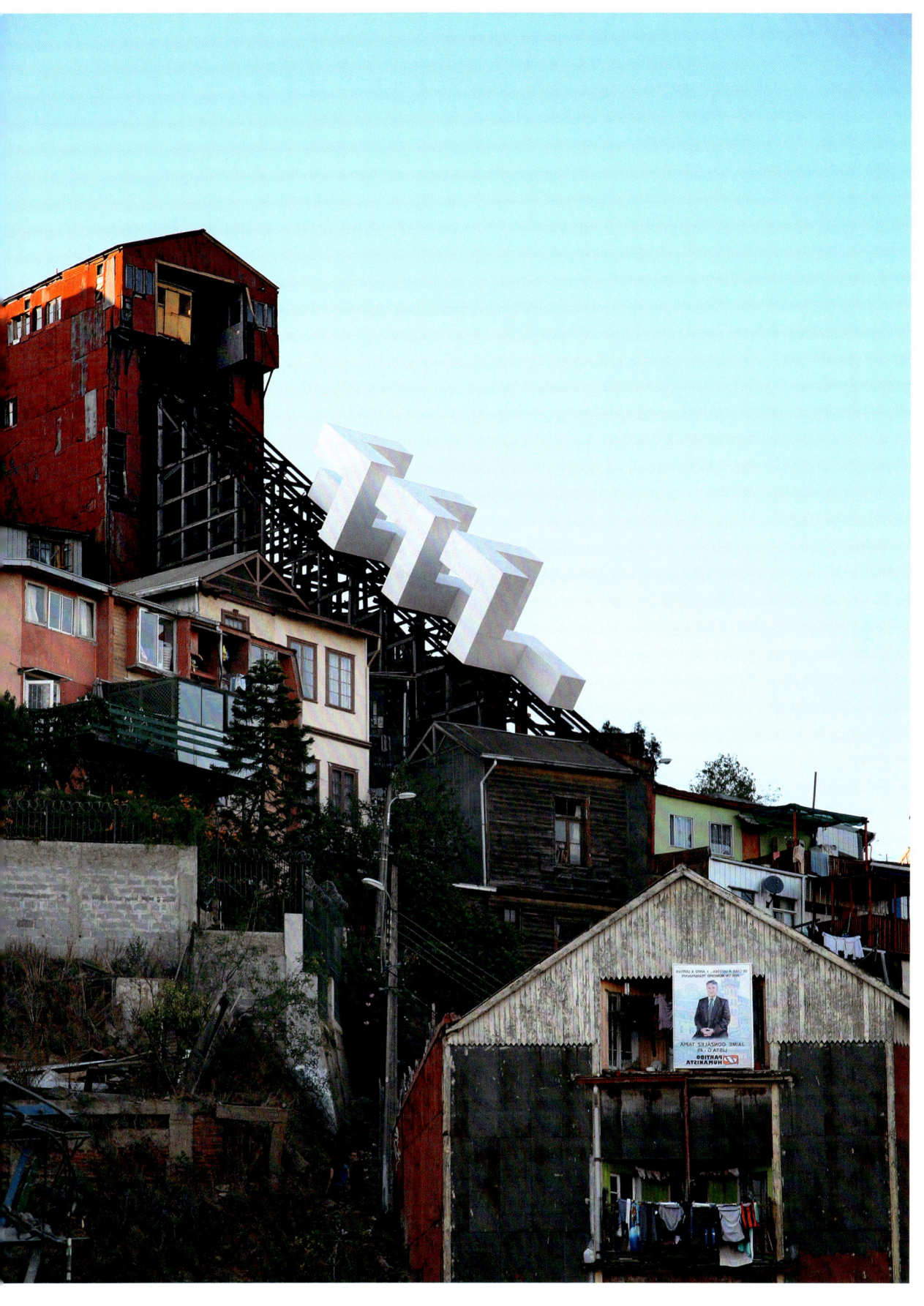

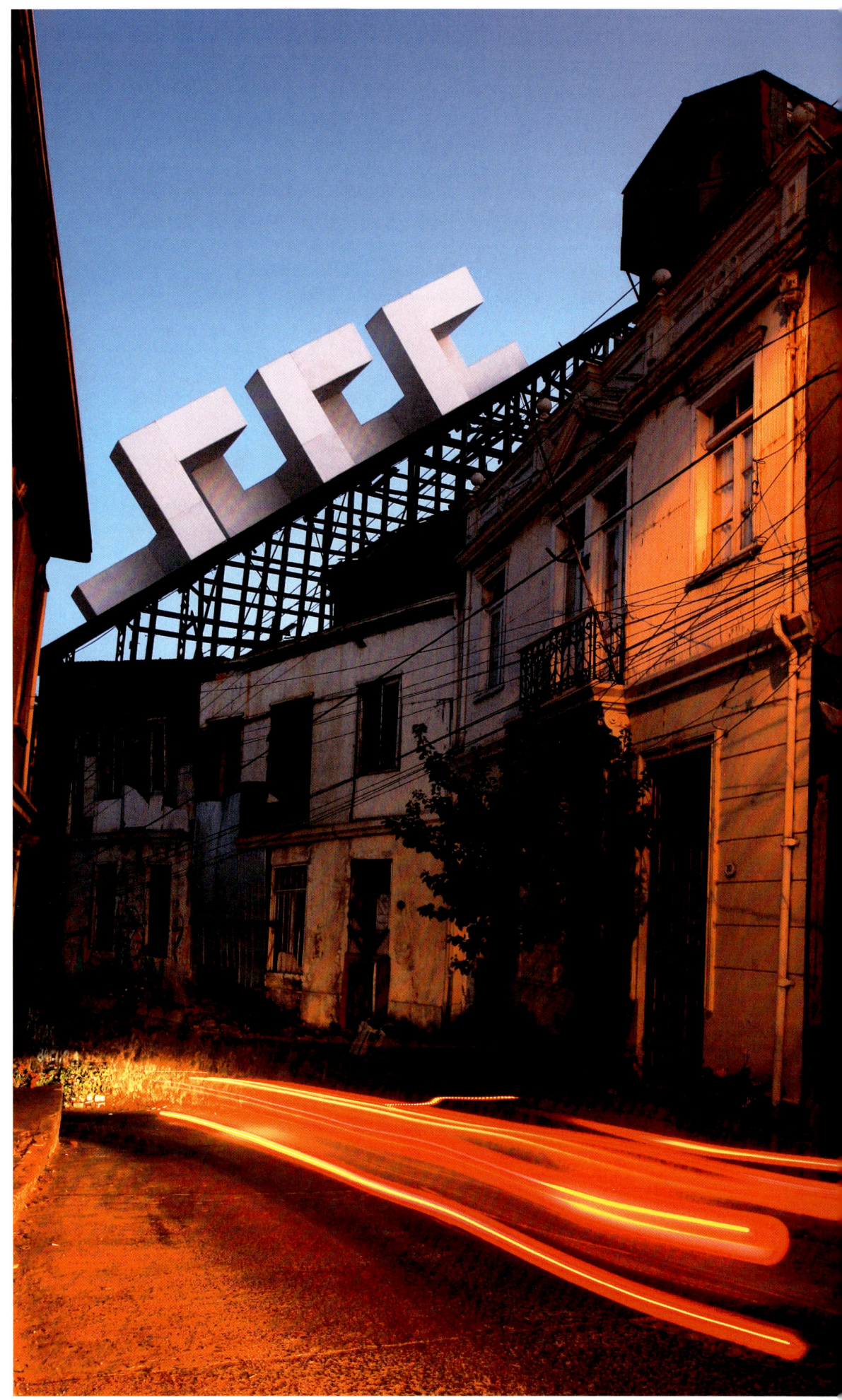

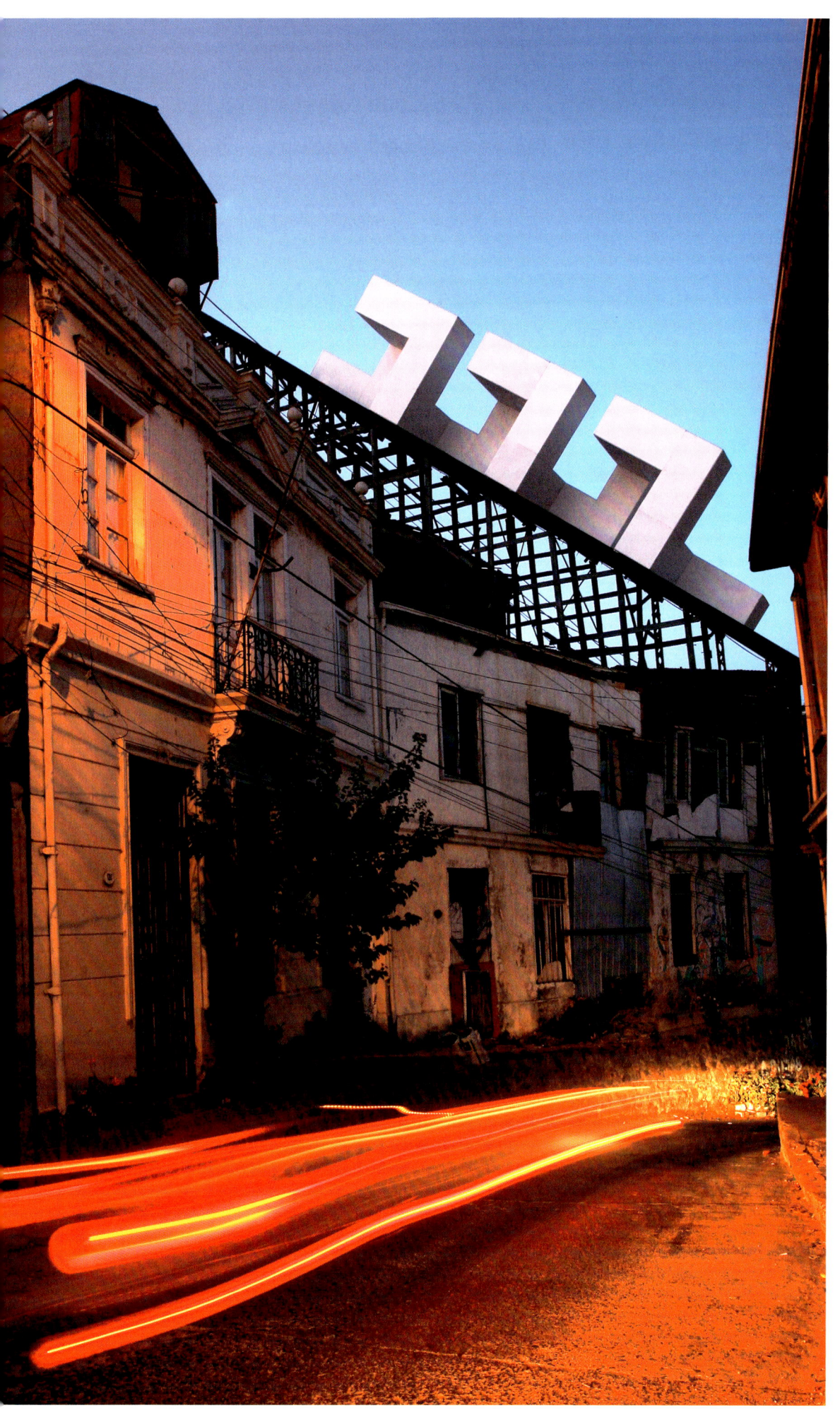

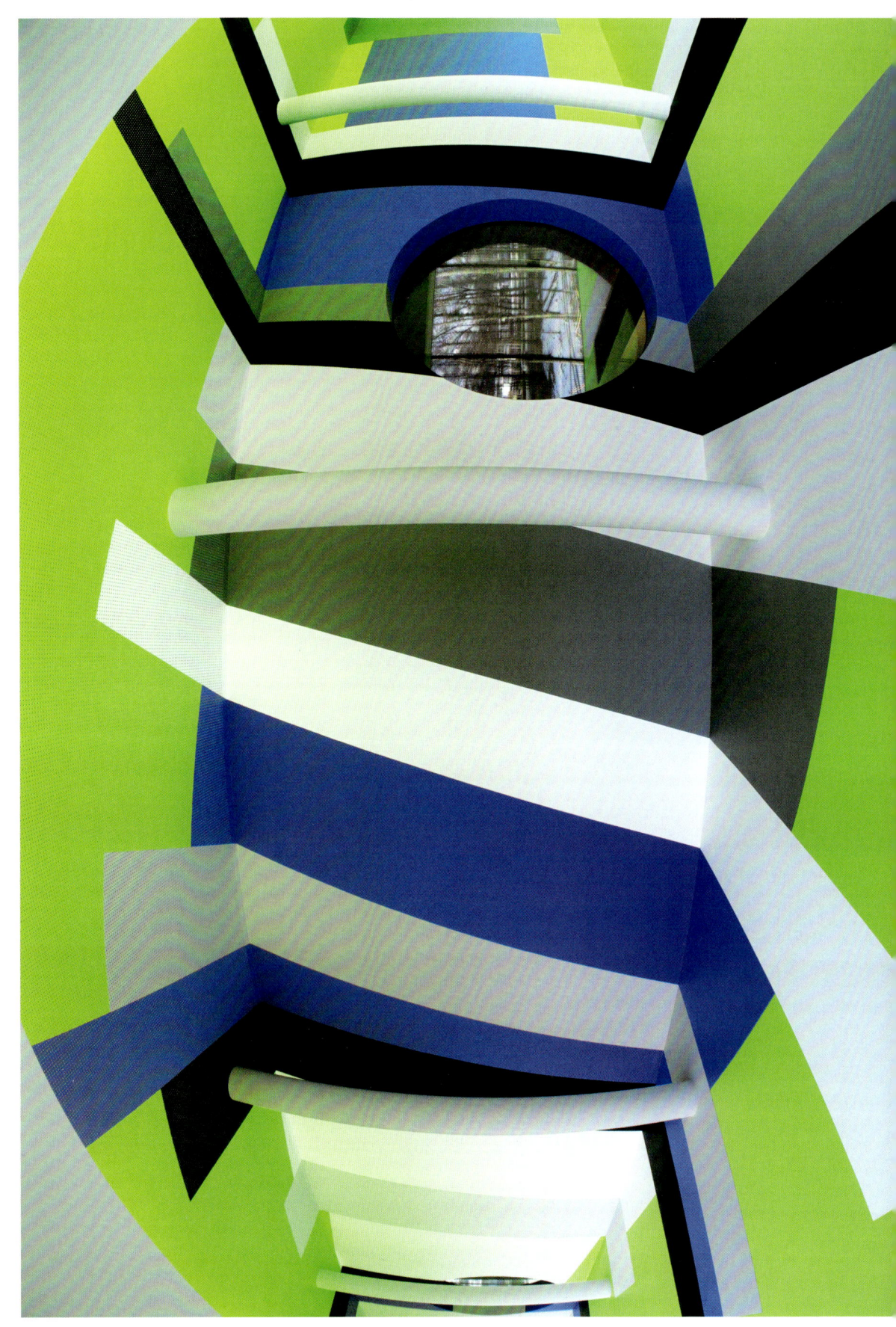

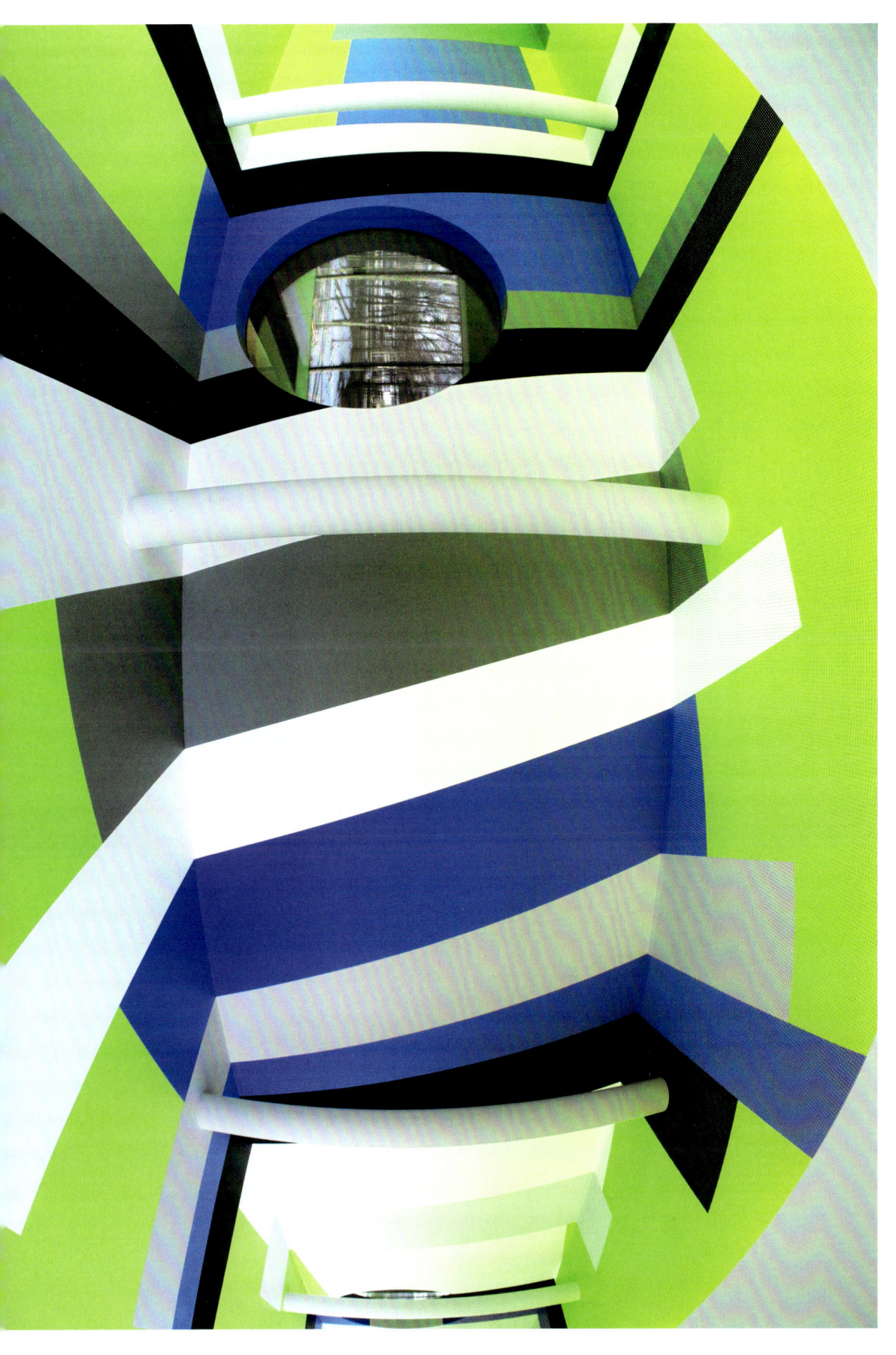

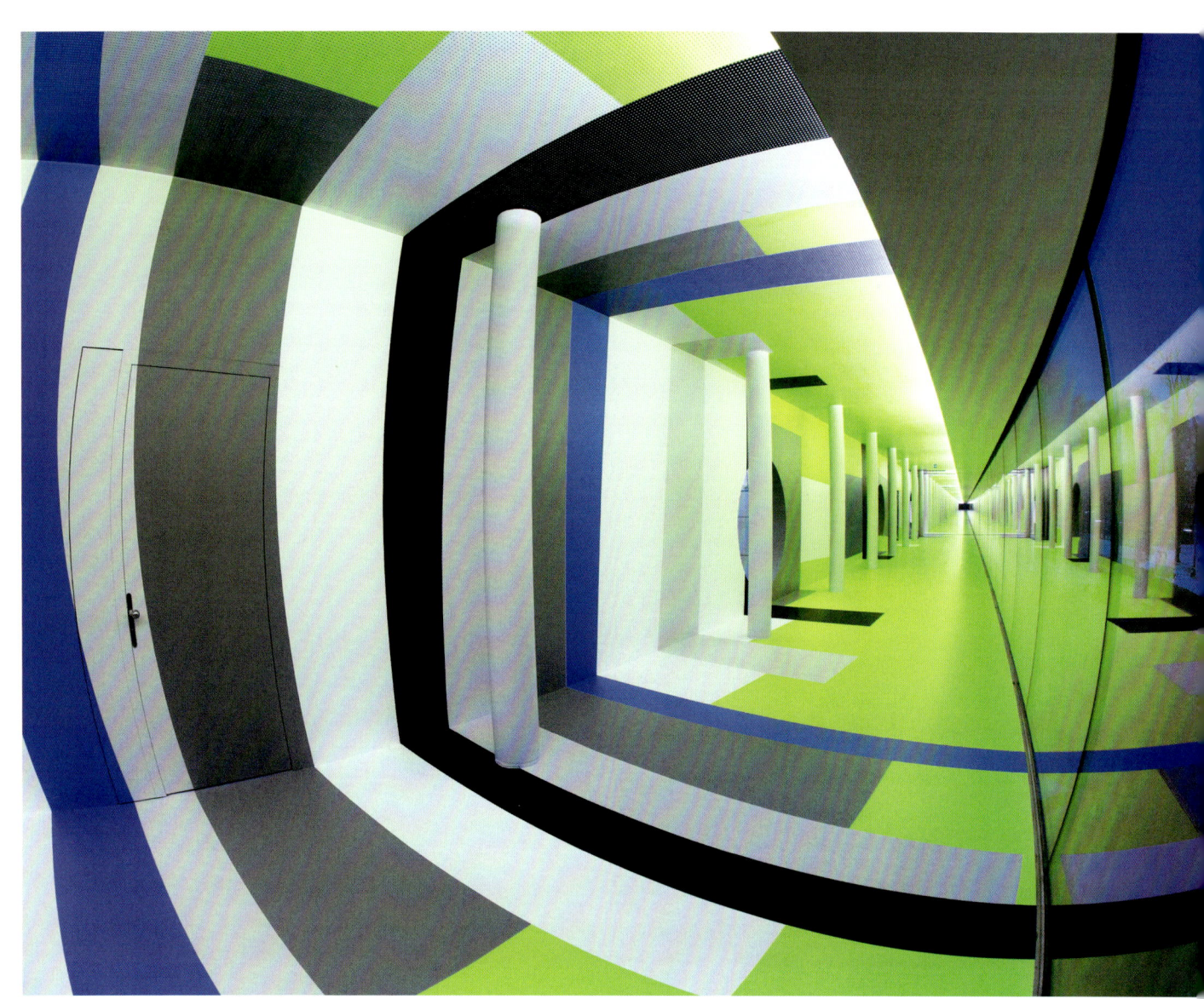

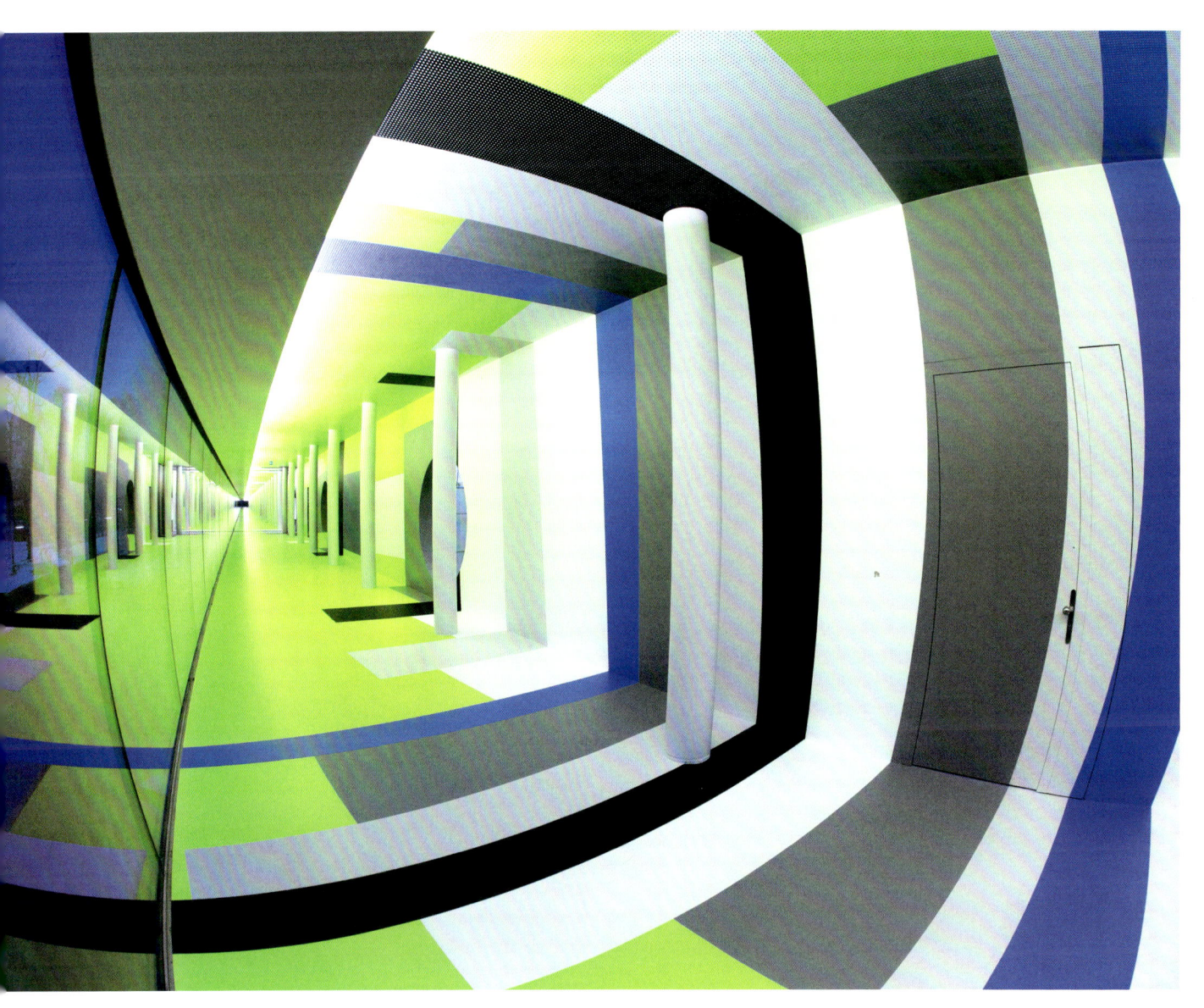

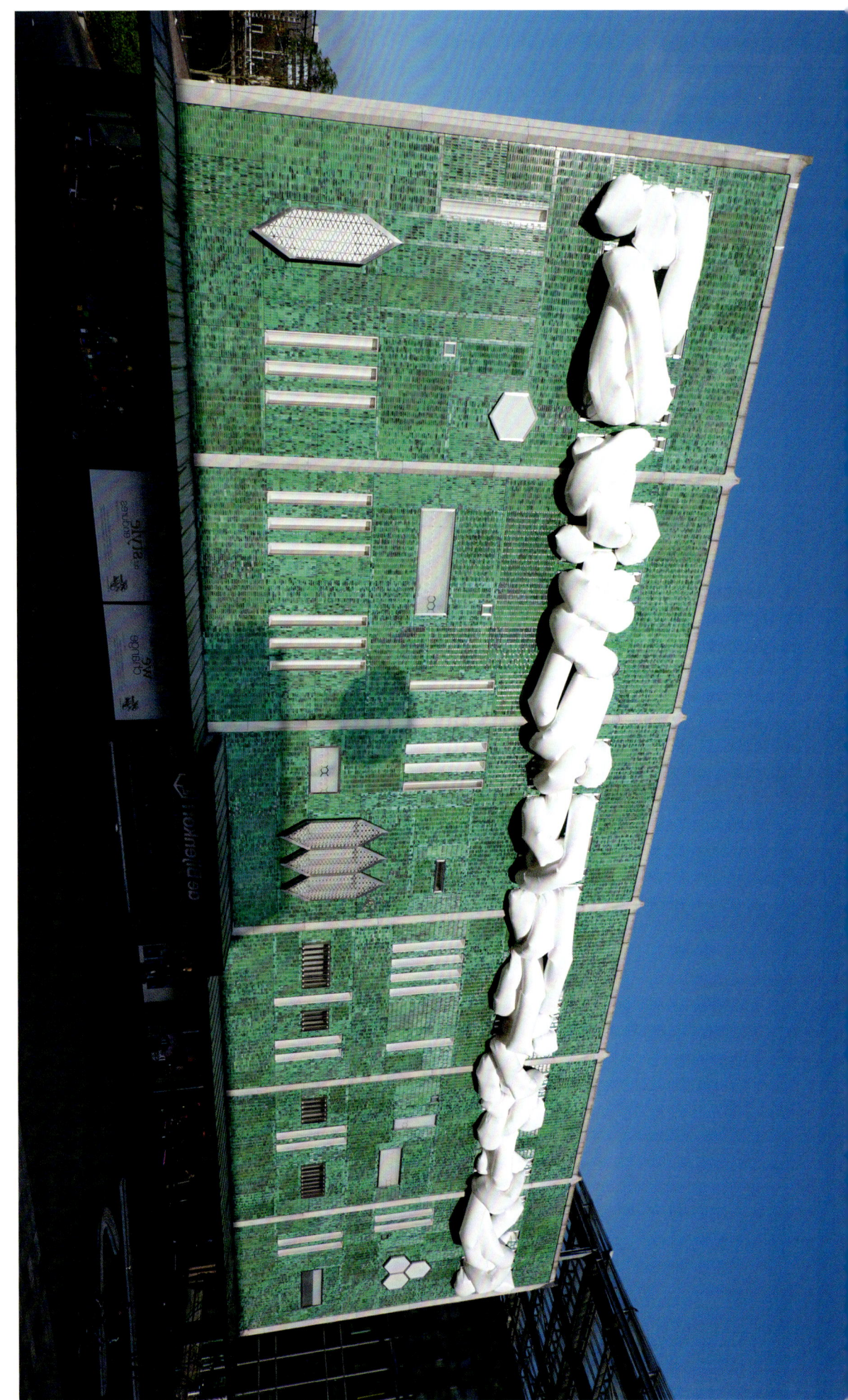

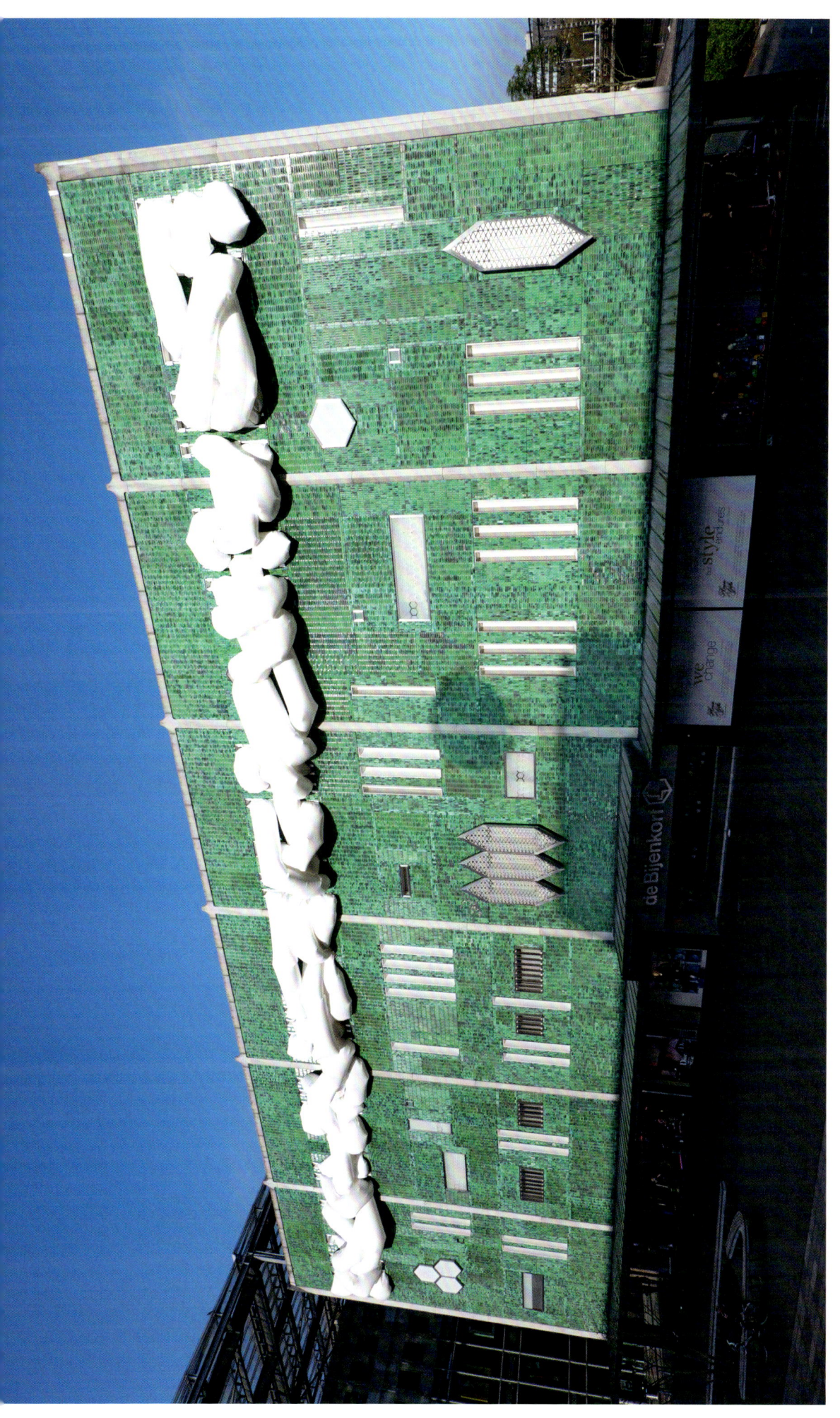

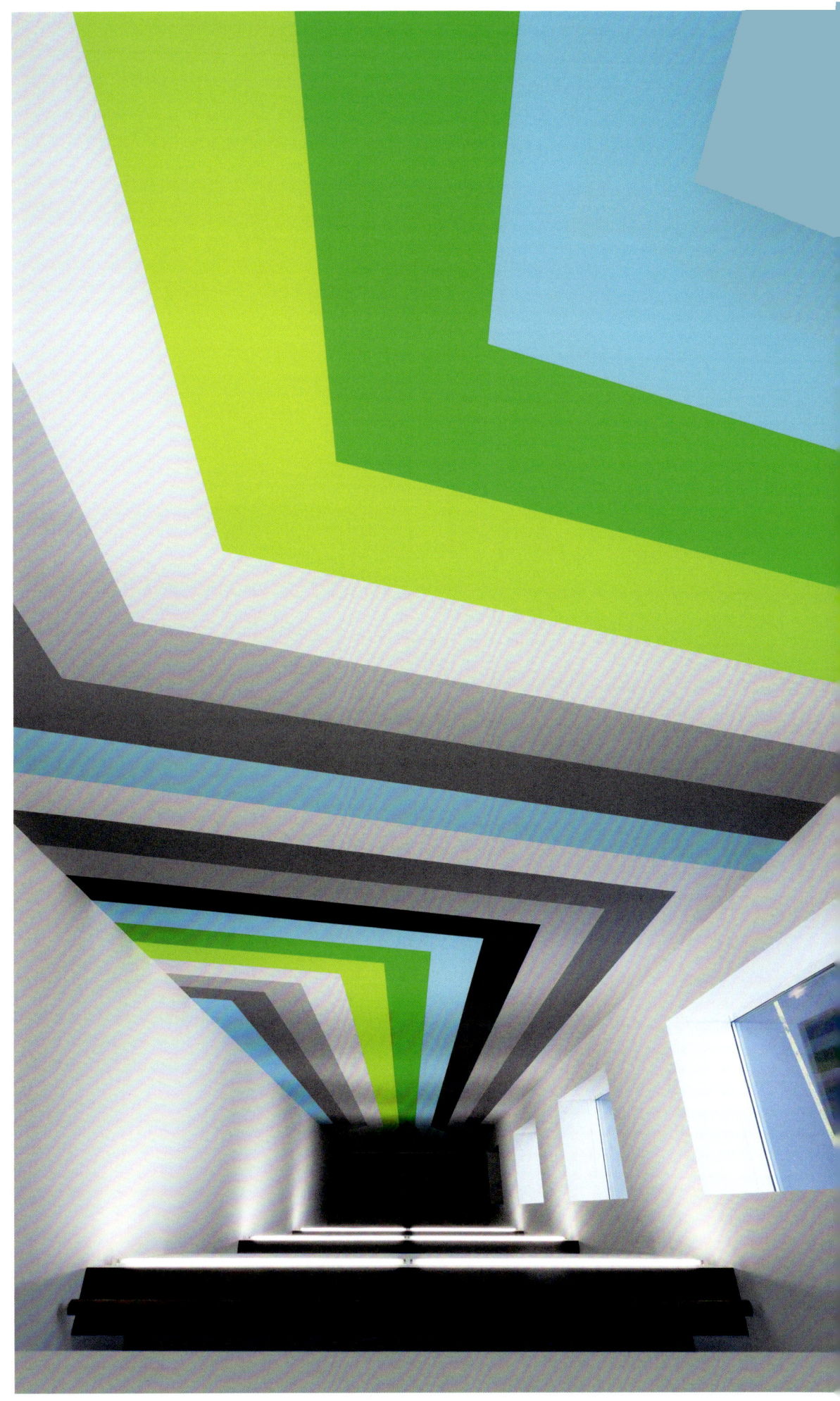

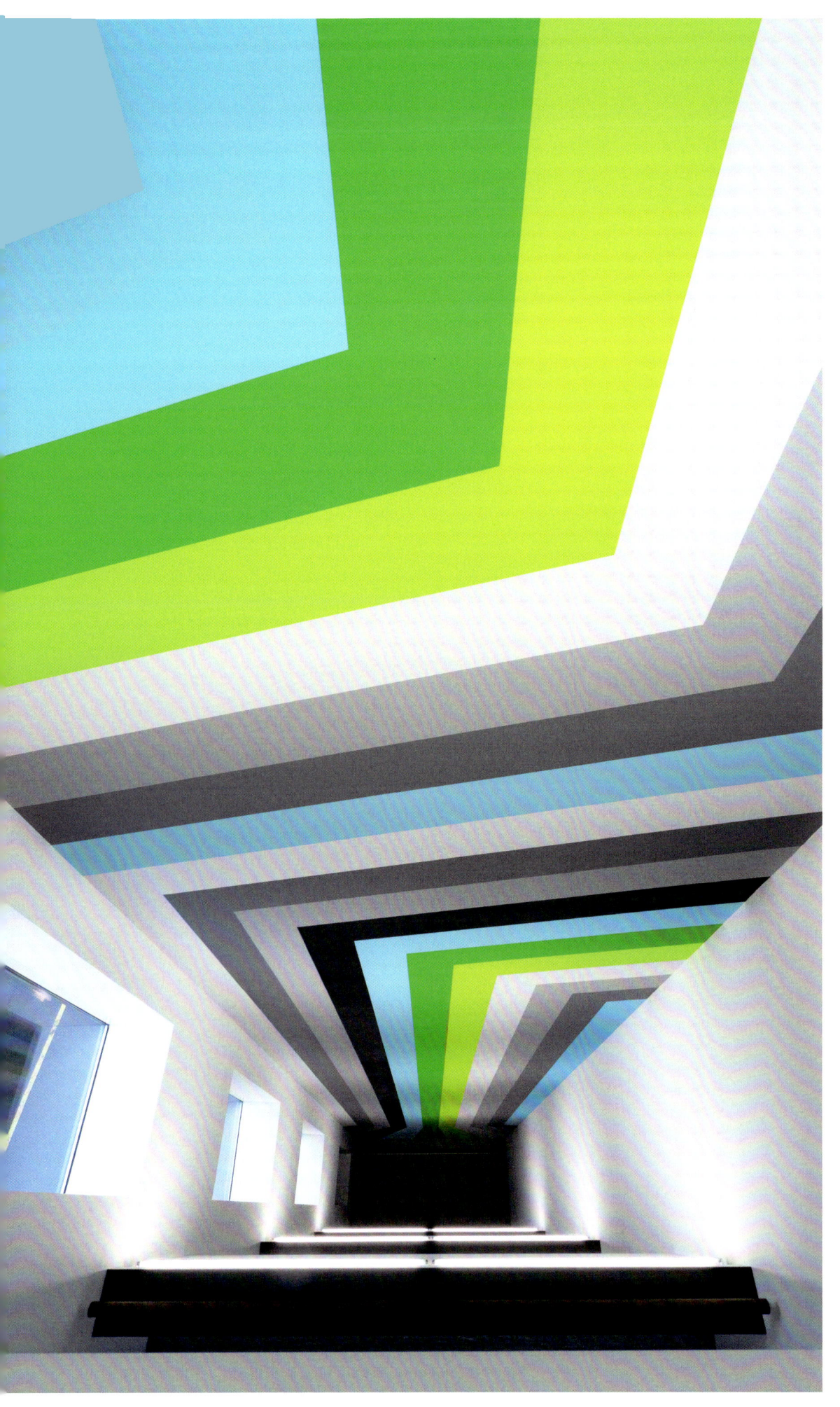

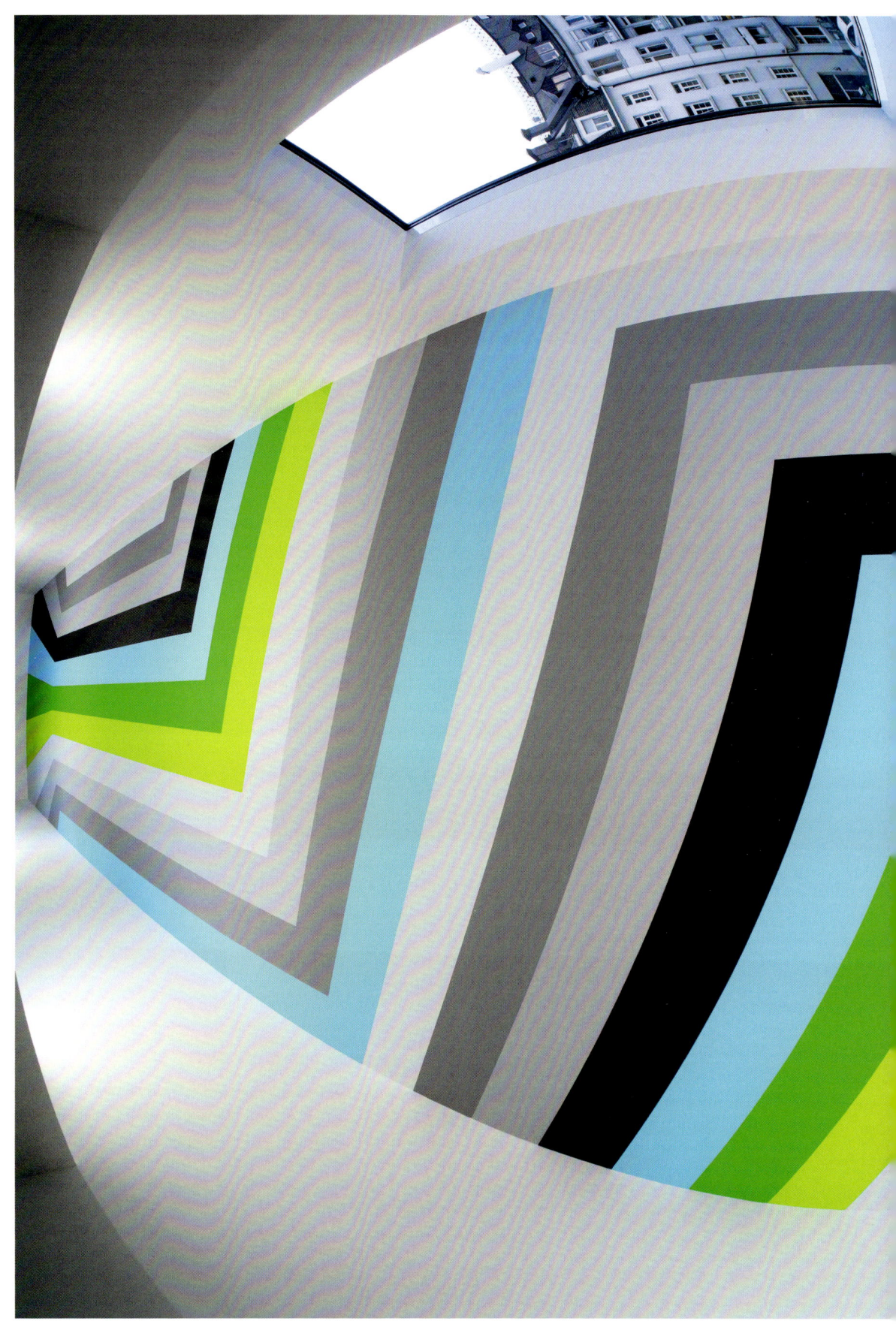

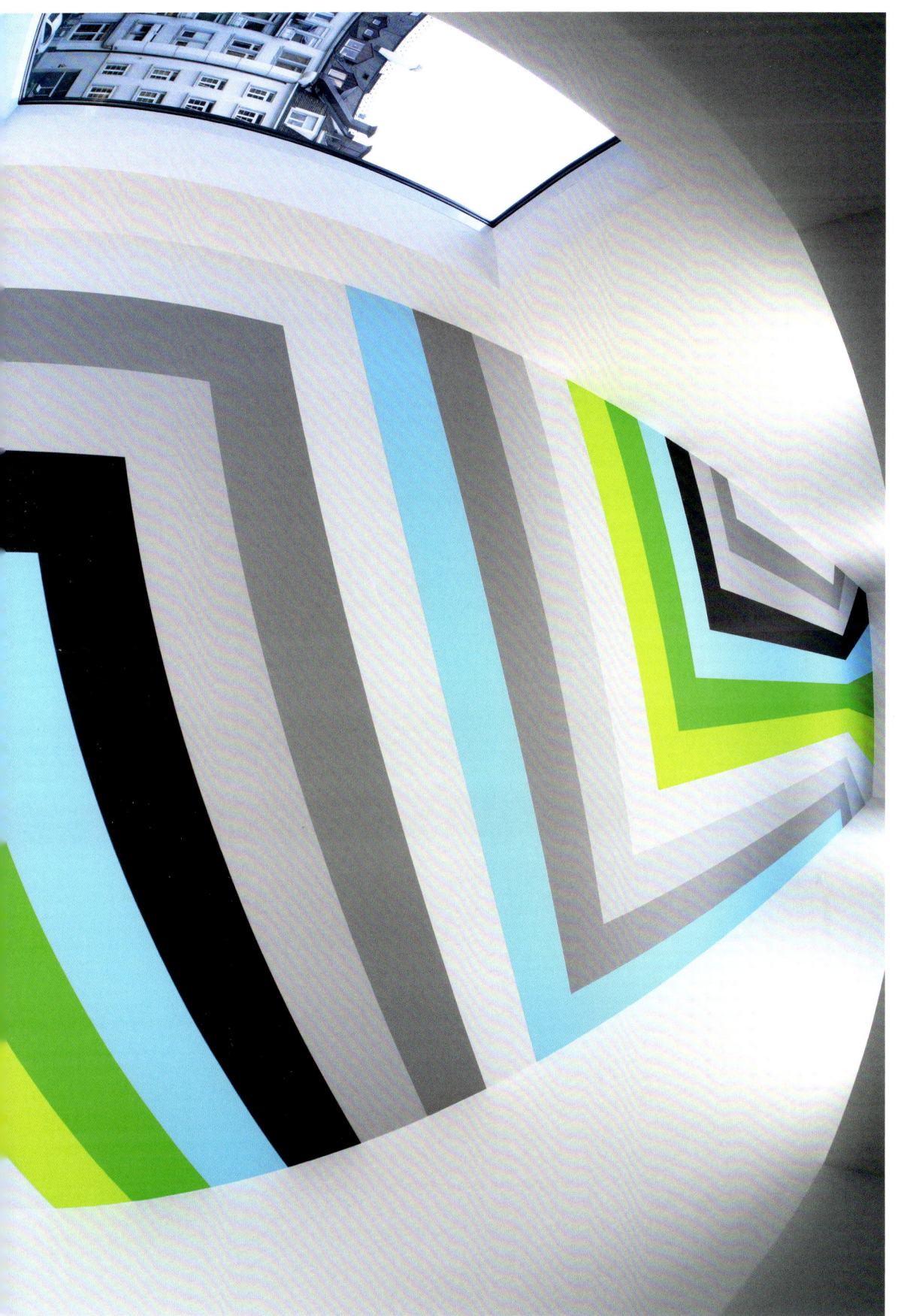

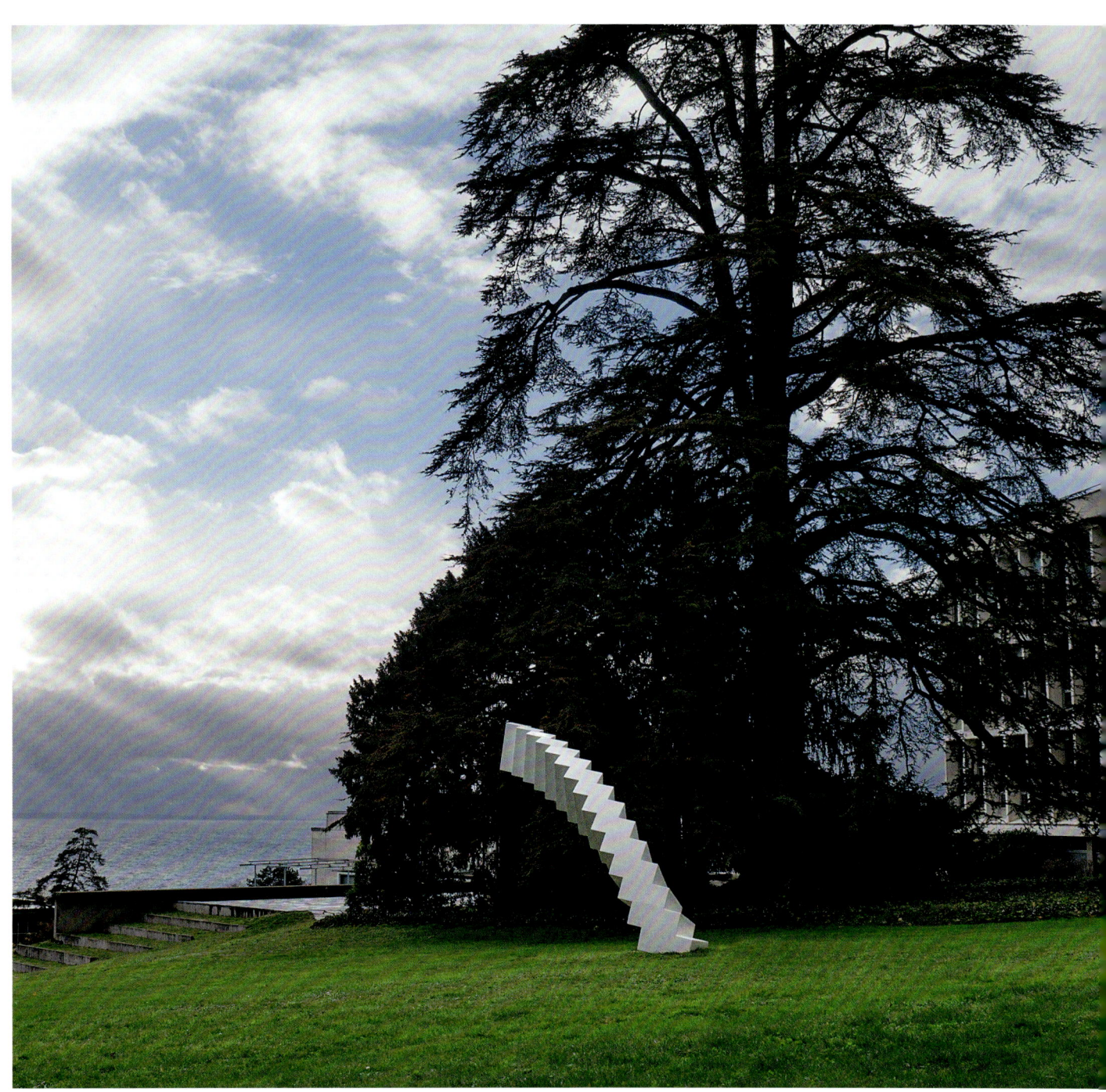

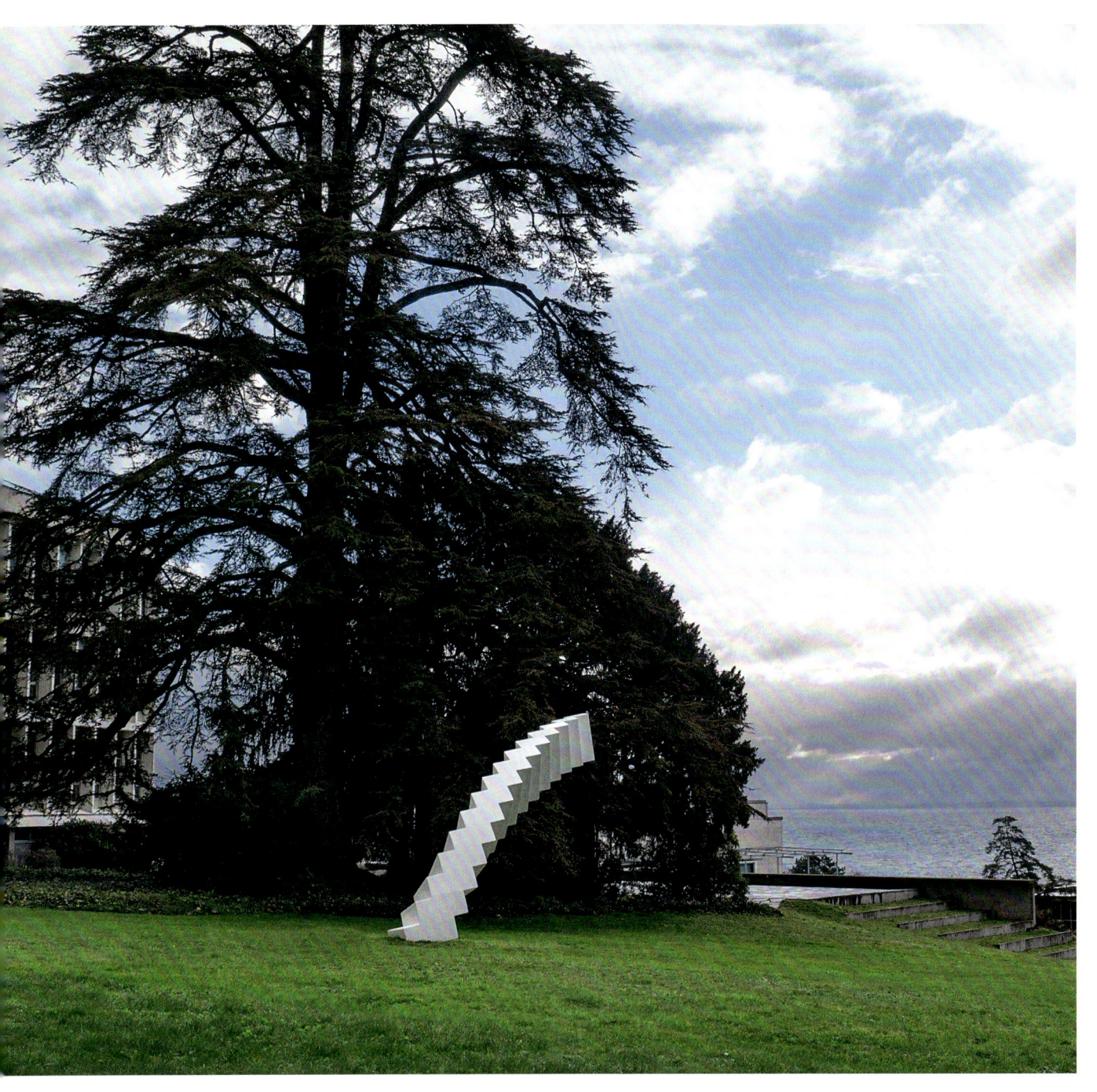

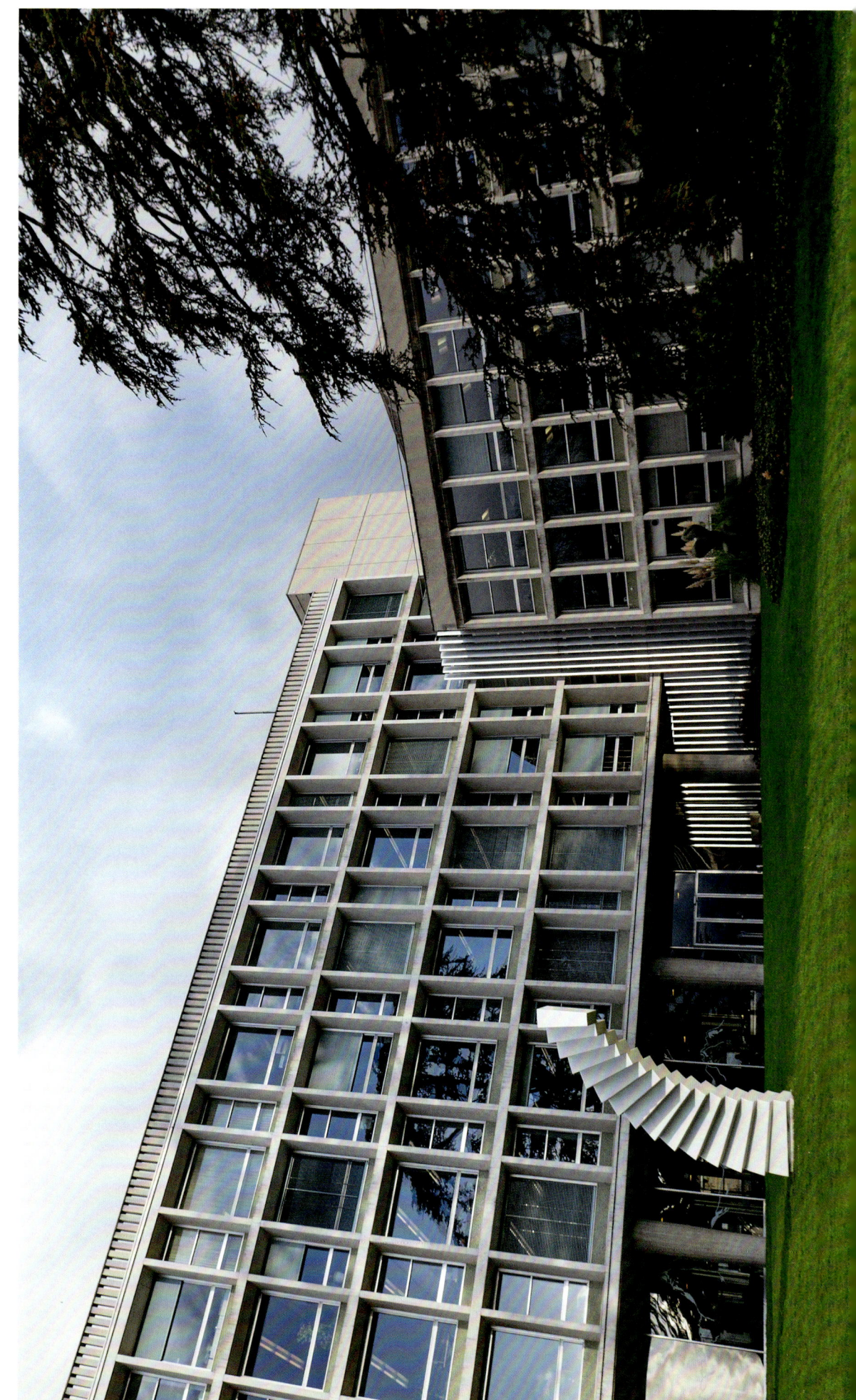

28

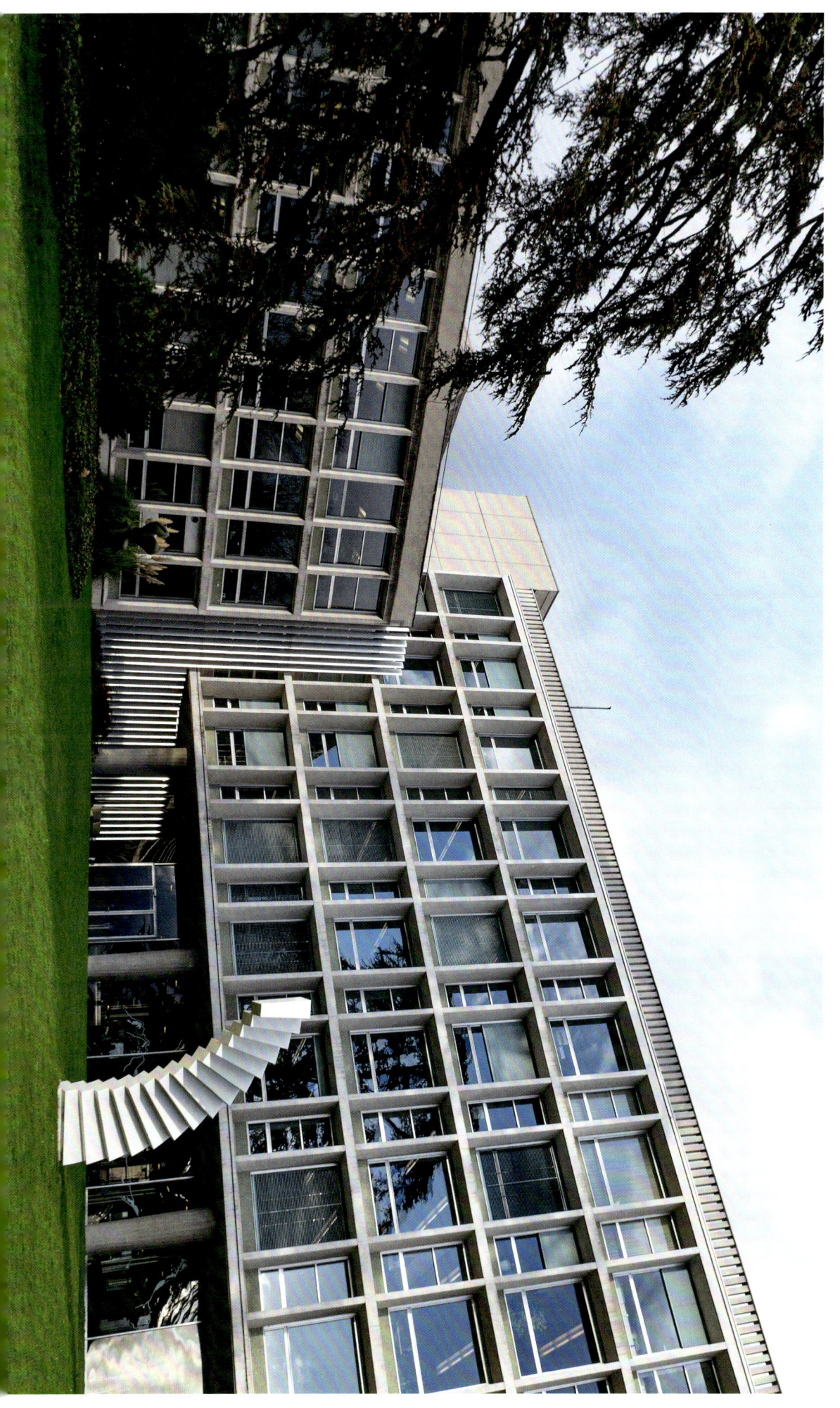

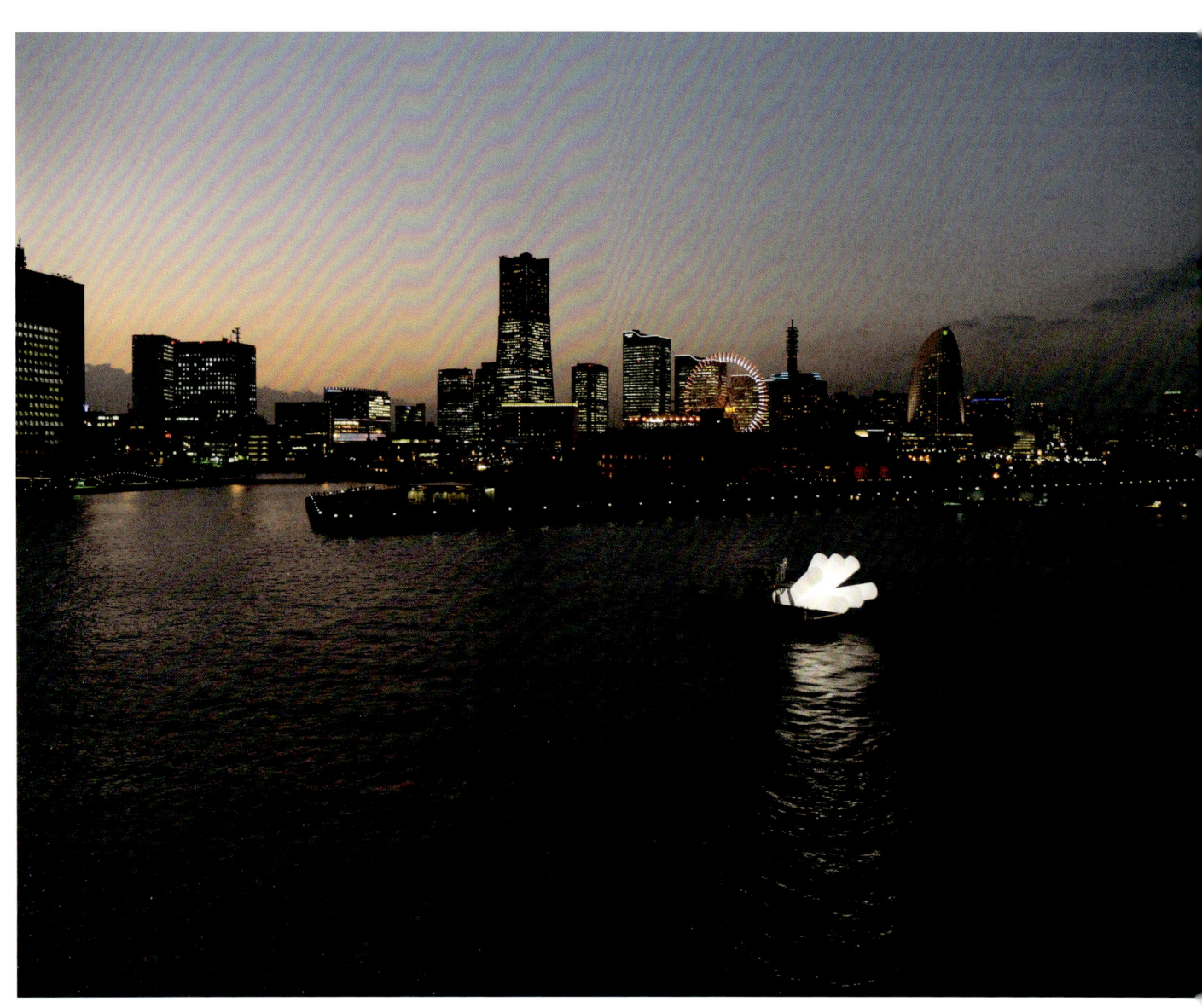

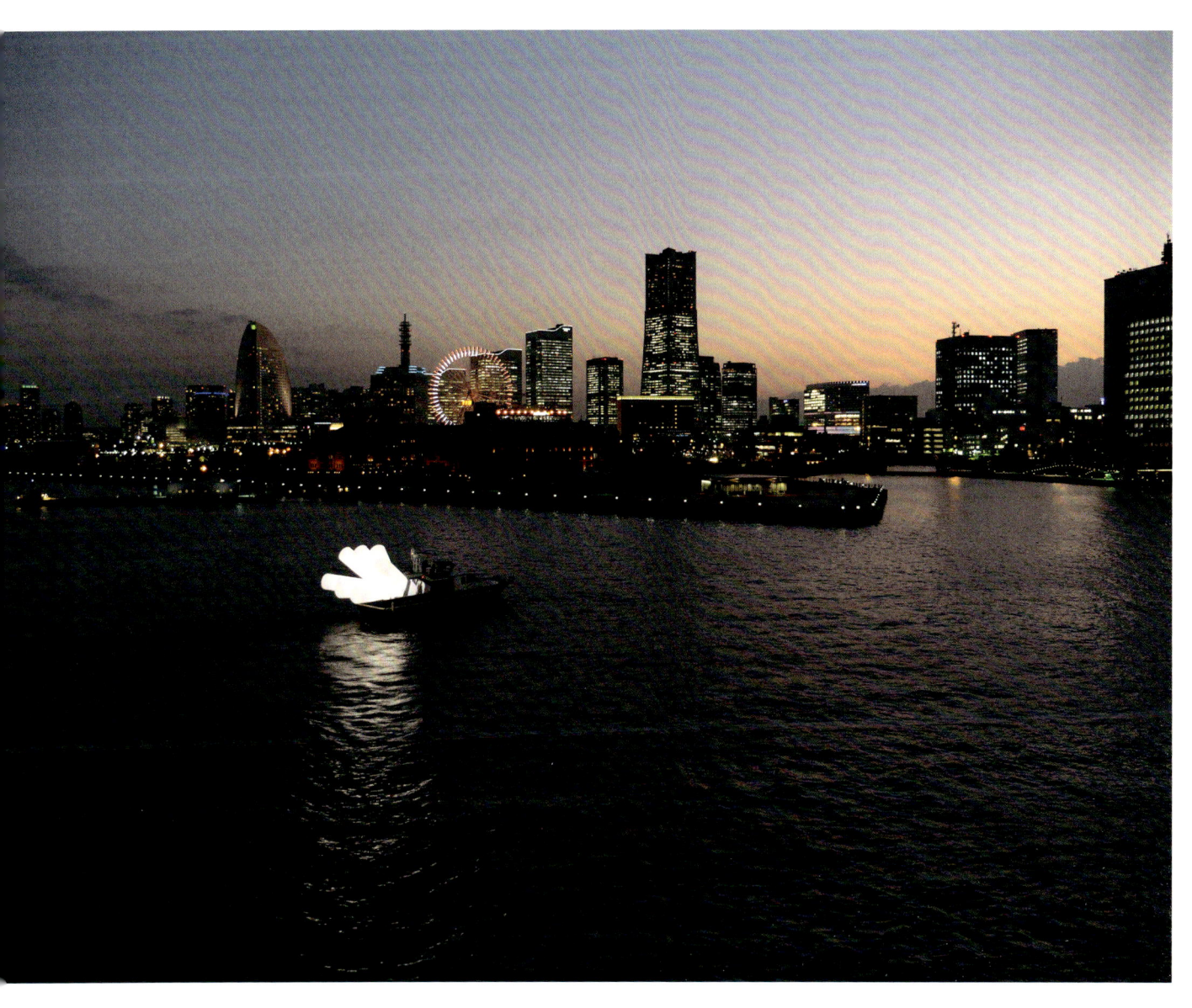

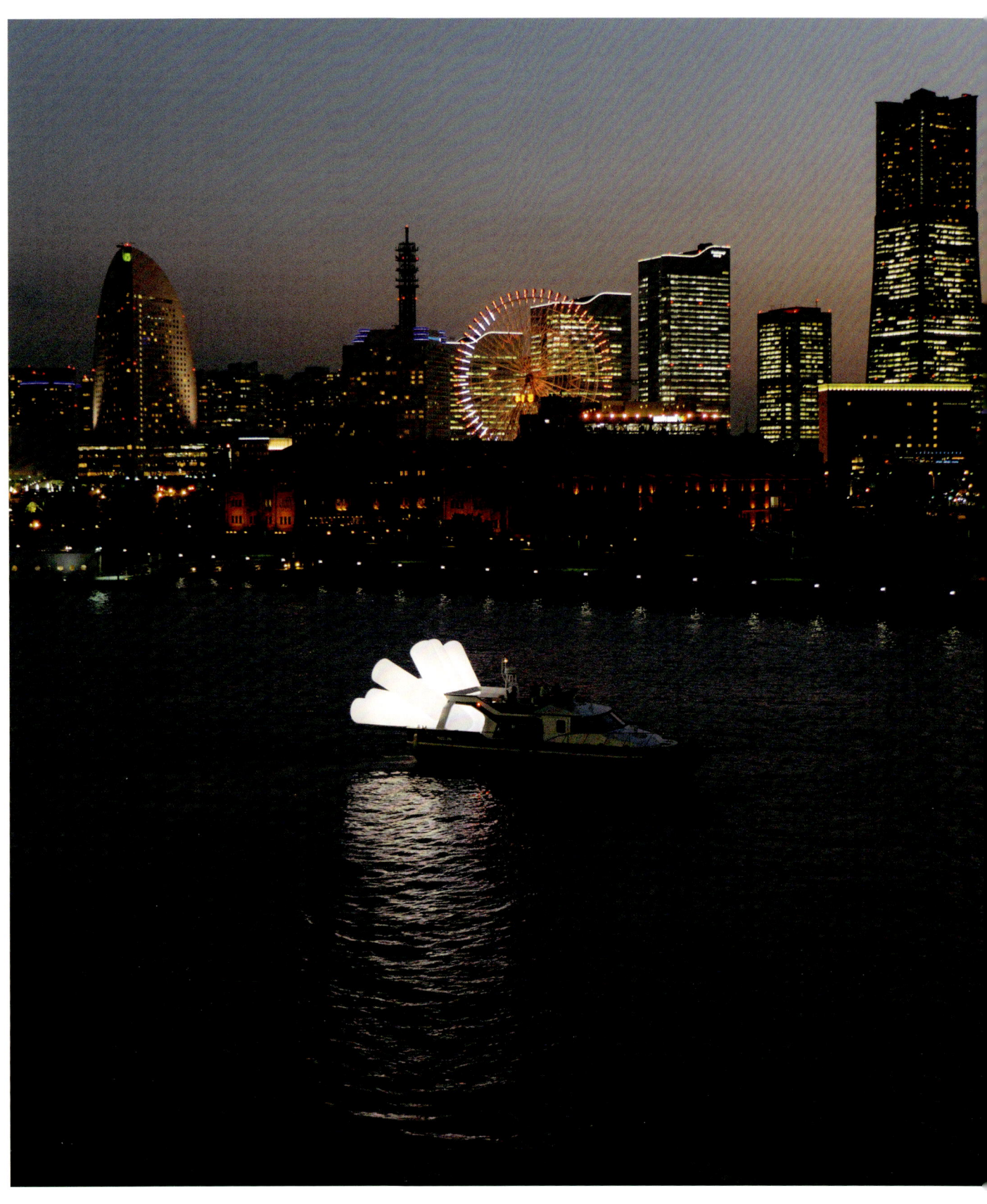

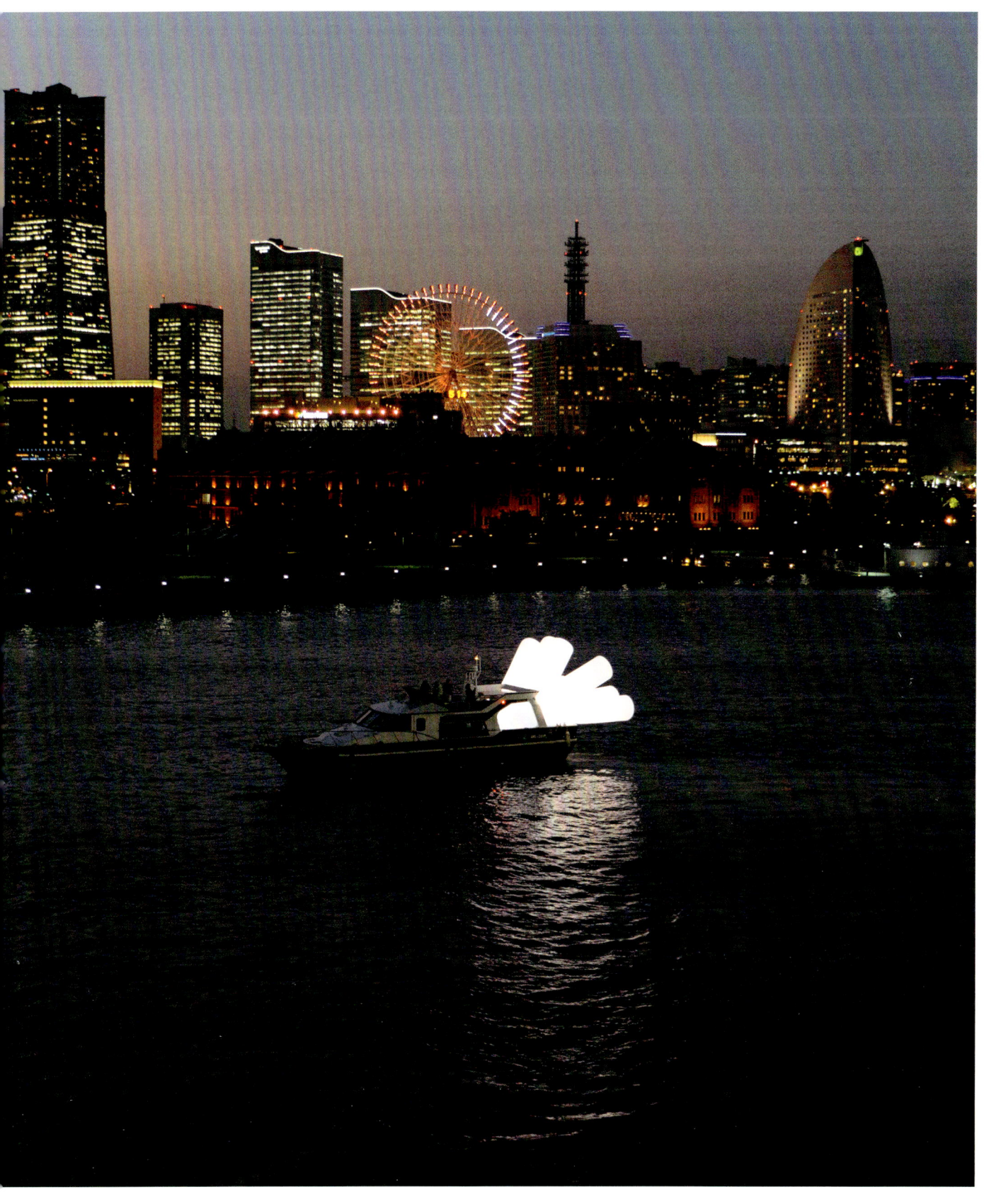

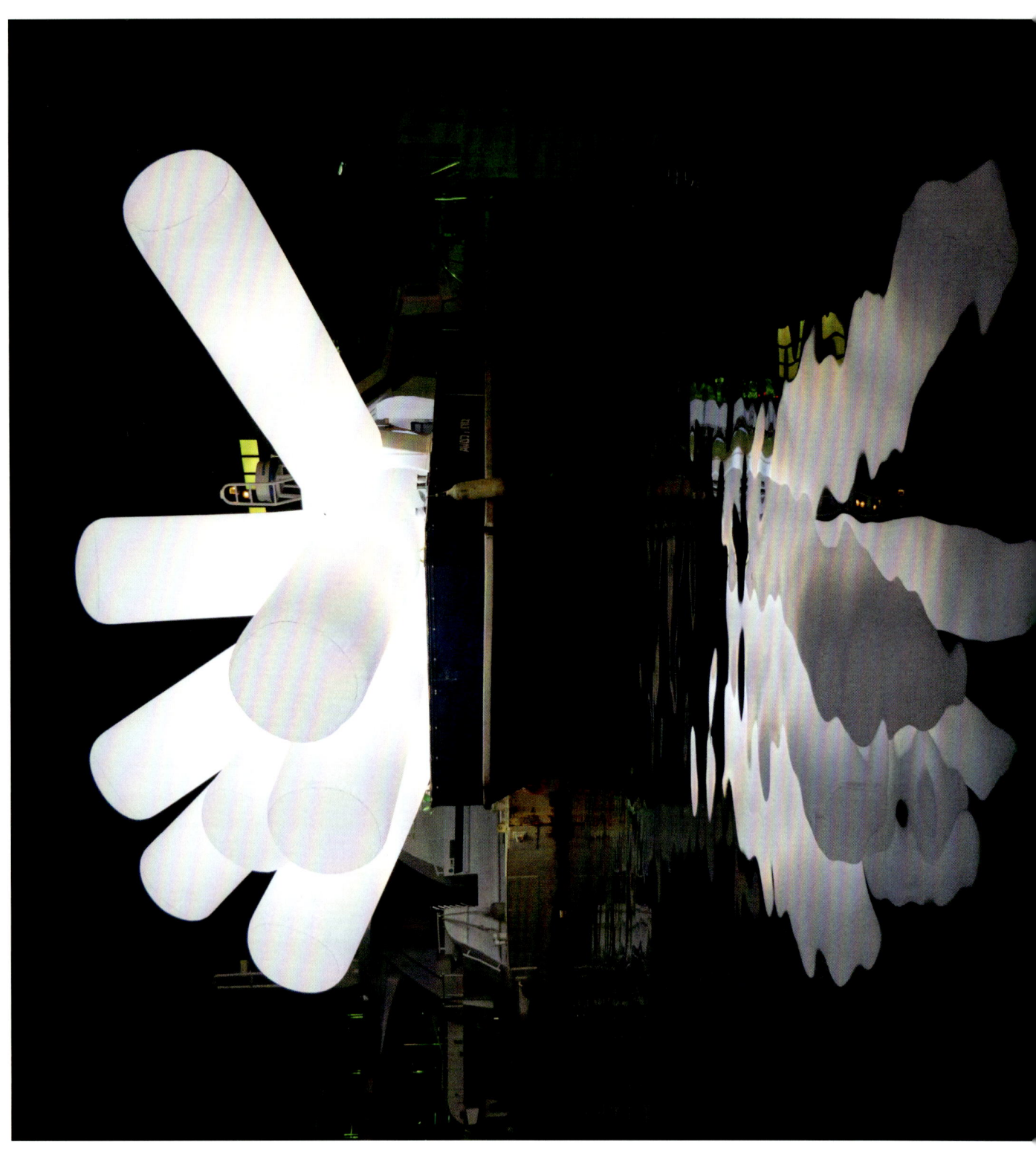

35

37

39

40

43

44

45

46

50

52

55

56

57

60

64

ea

72

74

08

86

87

e8

re

æ

97

ee

COMMUNE DE CARCONS
ECOLE

ггг

114

117

118

119

123

130

131

134

143

150

151

154

Lang/
Baumann
More
is More

Lang/
Baumann
More
is More

Content

2 Comfort #12
10 Spiral #3
16 Beautiful Wall #25
20 Comfort #4
22 Beautiful Wall #23
26 Beautiful Steps #9
30 Comfort #11
36 Open
42 Street Painting #3
50 Beautiful Walls #22
56 Shine #2
58 Comfort #6
62 Beautiful Tube
70 Street Painting #6
74 Comfort #4
78 Comfort #10
80 Wave #2
82 Beautiful Steps #8
84 Beautiful Entrance #6
88 Golden Table #2
90 Beautiful Bridge #1
98 Beautiful Steps #6

100 Comfort #4
104 Street Painting #5
110 Comfort #8
114 Comfort #6
118 Beautiful Steps #5
124 Beautiful Steps #3
126 Spiral #1
128 Spielfeld #5
132 Beautiful Walls #18
136 Der vierte Steg
138 Perfect #4
142 Beautiful Steps #4
146 Beautiful Steps #2
150 Spielfeld #4
152 Flash #2
158 Beautiful Carpet #1

167 Langanke/Spieler Imagination Engine
171 Akiko Miki The "Comfort" of Strangers
174 Fabrice Stroun Concrete Science Fiction
176 Sue Williamson A Poetic Insanity

187 Drawings
224 Works

Imagination Engine

Cathrin Langanke
Reinhard Spieler

A diving board is standing in the middle of a meadow with no water in sight; an inaccessible staircase floats in space; the lines of a soccer pitch turn into an ornamental drawing; tarmac becomes a vehicle for geometric abstraction; a sculptural object on the roof of a museum proves to be a mobile hotel room.

Sabina Lang and Daniel Baumann have been working as a team since the early 1990s, calling themselves Lang/Baumann (or L/B for short). During that time they have devised and created a body of work that consistently jolts viewers by undermining entrenched modes of perception. Their numerous groups of works—paintings, sculptures, installations and architecture—invariably target in-between spaces and defy classification or confinement to a specific genre. Their objects allude to functional procedures but they don't function.

As a rule, a specific combination of place, object and form yields a functional unit. By changing at least one of those coordinates, L/B subvert the supposedly self-evident parameters of perception. And by taking functionality to absurd extremes, they make astonishing things happen: on one hand, awareness of functionality is heightened precisely because it has been undermined. Nobody thinks twice about a ten meter diving board next to a swimming pool: there is nothing special about; it is perfectly "normal." But put it in the middle of a meadow and one begins thinking about what it is for. On the other hand, its aesthetic appearance is foregrounded because it has been deprived of its conventional context, making aesthetics obviously figure as its only remaining "function."

L/B reconfigure materials, patterns, structures and objects of everyday, industrial use, putting them in a new context to unexpected, surprising and sometimes even anti-functional effect.

Perception of their *Wall Paintings*, a series of geometrically constructed patterns in strong, contrasting colors, fluctuates between a flat image on the wall and spatial illusion. The paintings may spill over onto adjoining walls and ceilings or even occupy entire stairwells, inverting their functional priority: suddenly we find ourselves negotiating a painterly installation that monopolizes all of our senses—the stairs become secondary.

The artists' works move outdoors in the form of *Street Paintings*. Commissioned by the city of Zürich, L/B revamped an underpass for pedestrians and cyclists in *Street Painting #3* (2012). Starting from the usual middle line, the duo painted straight and curved bands of color in black, grey, white and magenta, with yellow traffic items tracing their edges. L/B undermined the function of road markings, namely to provide orientation, define boundaries and protect users from oncoming traffic. The unsettling result completely altered the perception of the underpass. Viewers found themselves in a no man's land between a space for traffic and an art space, and although the painting supposedly takes the guise of applied art, it is in fact the exact opposite inasmuch as it negates the traffic function of the space.

More recent works in the *Comfort Series* consist of inflatable installations that fill entire rooms and engage in a dialogue with the architecture. Inflated tubes define the contours of spaces, at times almost morphing into architectural elements themselves. Pushed through windows, the tubes move outside, spreading out on façades, circling around roofs and even around entire buildings. Once again, we find ourselves in the realm of in-between spaces: rooms, that is interiors, are turned inside out; hollow spaces become solids. The in-between space is actually the work itself; it has literally been blown up and consolidated.

Open (2012) foregrounds the building itself. Instead of adding a structure or architectural elements, the artists removed all of the windows and doors in a small building, a former waiting room converted into an off space known as the Grand Palais. The resulting spaces were linked and painted to create pink corridors through which visitors could peer and walk.

Hotel Everland, a mobile hotel room, which is not simply entered but actually used, was created on the occasion of the 6th Swiss National Exhibition in 2002. This work, L/B's most famous production to date, is a small sculptural building, its every detail meticulously designed, and at the same time a fully functional hotel room. Where- and whenever it is on display, the one-room hotel can be booked for only one night. The guests are absorbed into the work of art as performers in the limbo of *Everland,* where art and everyday life have become indistinguishable.

After Expo.02 closed down, the hotel room itself was cast as a guest, spending one-and-a-half years each on the roof of Leipzig's Gallery of Contemporary Art and the Palais de Tokyo in Paris. The latter location offered overnight guests a breathtaking view of the Eiffel Tower and pedestrians a distinctive roof sculpture visible from afar.

L/B have created a new work for the Wilhelm Hack Museum (WHM). The open architecture characteristic of the museum is mirrored both inside and outside the building. Not only is the main entrance glazed but also much of the façade around the building, affording a view of the interior. The architectural concept underlying the design of the museum is evident inside as well, where easily navigable galleries extend over several floors. In the course of the museum's history, now spanning more than three decades, the openness and spaciousness of the original architecture has been surrendered to make room for numerous modifications.

The Wilhelm Hack Museum in Ludwigshafen was planned in 1973 and construction completed in 1979. The openness of the original architecture reflects the wish of the institution's benefactor, Wilhelm Hack: "I want to create a museum, not a mausoleum. The building should be a place of encounter."
The city concurred with this wish, as demonstrated throughout most of the building: the transparent façade, the design and arrangement of the lobby, and the layout of the galleries. The building offers visitors a clear overview of elements that flow into each other while at the same time defined by a syntax that takes its cue from brutalist and structuralist architecture.

This architecture, in combination with the pervasive dominance in the city of the chemical production plant BASF, became the point of departure for L/B's approach. They first had all the temporary walls in the galleries removed in order to open the building up, revealing its original philosophy. They then worked out a spectacular, monumental installation that treats the entire space as a single unit and displays a formal idiom that relates to the rough, industrial feel of the museum's fair-faced concrete. The installation consists of inflatable tubes that run through the entire building like pipelines, responding to the openness of the flowing connections in the building and, of course, also evoking associations with industrial production. These groups of pipelines interact with large-format, abstract wall paintings in strong colors, which in turn establish a connection with the building itself and its landmark façade showing a 55 meter long work by Joan Miró.

Visitors already encounter the first wall painting in the lobby when they approach the stairs leading up to the area for special exhibitions. With their wall-sized painting *Beautiful Wall #27* (2013), LB have center staged a wall that is actually meant to screen the stairs off from the exhibition space and is therefore rarely taken into account in the hanging of exhibitions.

But L/B not only activate those neglected and ordinarily ignored in-between spaces; at the same time, as clearly manifested in Ludwigshafen, they have successfully established new connections. Complemented by *Beautiful Wall #28* (2013) and *Beautiful Wall #29* (2013), wall paintings on the two rear walls on the southwest side of the museum, these paintings, applied directly to the walls, break up the white planes with their luminous colors. The abstract motifs generate a sense of depth that gives viewers a feeling of expanding space. Placed in the entrance area and to the left and right at the back of the gallery for special exhibitions, the three paintings form a frame within which the second work, the inflatable installation *Comfort #12* (2013), can literally spread out.

The exhibition area is entirely filled with an installation consisting of 28 fully inflated, silver grey pipes made out of a synthetic textile. With a diameter of 95 cm and up to 45 m in length, these pipes, divided into seven units, make their way through the galleries. Since the air can escape along the lengthwise seams, the pipes are connected to inflator fans to ensure that the air pressure inside them remains constant. The optical and spatial event is thus acoustically accompanied by the hissing of the escaping air and the noise of the fans. The pipes run parallel across the floor in groups of four and trace the shape of the museum: its steps, walls and ceilings. They interact with the architecture and radically alter the impression and feel of the space.

As in *Hotel Everland*, with its completely glazed front drawing the outside world in, the distinction between outside and inside has essentially been eliminated in the WHM as well—L/B had all of the built-in exhibition walls removed, which obstruct views from inside and outside through the wide glass front. In that way, the originally flowing spatial concept of the architecture came to the fore again as a concrete experience. The room-filling installation of gigantic inflated tubes

looks as if the massive interwoven tubes on the façade of the Centre Georges Pompidou had been turned inside out and squeezed into the WHM, which was built at the same time.

Just as the Centre Pompidou has occasionally been dubbed "La Raffinerie," one is, of course, instantly reminded of the BASF pipelines in Ludwigshafen, home to the chemical industry and the BASF's concentration of steam crackers, the core of the production plant, not far from the museum. Once again L/B transport us into a space situated between art and industry: has the industrial plant "rhizomed" into the museum or has the museum adopted the production methods of globalized industry, is the pipeline machinery now working under the auspices of art?

The space in between has become a space of thought and imagination, open and permeable from both sides, and functioning as a model in both cases. And so L/B have transformed the museum into an image incarnate of what an art space should ideally be: an imagination engine.

The "Comfort" of Strangers

Akiko Miki

Traveling is a brutality. It forces you to trust strangers and to lose sight of all that familiar comfort of home and friends. You are constantly off balance. Nothing is yours except the essential things: air, sleep, dreams, sea, the sky—all things tending towards the eternal or what we imagine of it.
Cesare Pavese

Lang/Baumann's installation *Comfort #6* was realized on the small island of Megijima within the framework of the first Setouchi International Art Festival in 2010.[1] This triennial event is an extension of the ambitious projects that have been organized at the Benesse Art Site Naoshima in the archipelago of the Seto Inland Sea for more than twenty years.

The relationship between art and architecture has been one of the most significant themes of the various projects realized in this context: artists and architects, such as Tatsuo Miyajima, Tadao Ando, James Turrell, Shinro Ohtake or Hiroshi Sugimoto, remodel and transform the space of old abandoned houses or old shrines into works of art. The architect Hiroshi Sambuichi and the artist Yukinori Yanagi turned the ruins of a copper refinery into an art museum using natural energy that minimizes the impact on the environment. Another new type of museum was created by the architect Ryue Nishizawa and the artist Rei Naito, an open concrete shell-structure without pillars that lets in wind, rain, sound and light from the outside, uniting art, architecture and nature. Through these innovative projects, the interplay between architecture and works of art, and their integration into rural landscape and existing environment, cultivates and extends a rich experience into everyday life.

While many of these permanently installed projects are oriented to create unique spaces (with often a meditative or even sacred atmosphere), Lang/Baumann's temporary installation in Megijima looked as if a kind of spaceship had suddenly landed in the middle of a village near the beach. Seen from above, it appeared as if the disused nursery school had all of sudden come to life: air-filled tubes escaped from the windows, cushioning the roof like a tubular gold membrane. This temporary, transitional alteration by an act of simple addition to the existing architecture or landscape is central to many works by Lang/Baumann, in which they generate a dreamlike vision of exceptional scenery. The artists' principal aim lies in collaborating with the existing site, trying to understand the space rather than realizing a visual presentation as a final goal. In other words, they are more interested in investigating what will happen in the existing setting through their intervention (their relationships, influences, interactions…) rather than in creating a space as such.

Lang/Baumann's different inflatable works are often installed in a kind of interspace: this shapes the volume of these "negative" spaces, providing different perceptions of the building's structure and spaces. Through their use of a specific design—curiously mixing retro and futuristic, rational and pop, mechanical and organic—they create, as described by David Spalding, "new connections between and within existing spaces and sets, and a desire to activate otherwise aesthetically neglected zones of connection (hallways, stairwells, etc.)"[2]

By triggering the imagination of the viewer, the connections are more complex, going beyond the traditional Japanese landscape at Megijima and extending to the social and historical. For example, the color gold could remind one of the legend of a monstrous ogre and a treasure that was once believed to be stored in the cave near the highest peak of the island —also known as Onigashima (island of ogres)—and the fact that the Seto Inland Sea was once frequented by pirates. Since the discovery of the cave at the beginning of the 20th century, the remains of a man-made quarry have been associated with the legend about Momotaro, a brave boy who fought the ogres living on the island. It is a popular Japanese story that has been told to scores of preschool children over the years. But now, like many other rural areas in Japan suf-fering from depopulation and an aging society, there are no children, so the nursery school is temporarily closed and has become another kind of "neglected space."

In this setting, connecting and exploring neglected space can also mean addressing social issues. Awakening critical attention to such environmental problems associated with modernization, while developing each island's distinctive culture through art and architecture, is indeed one of the fundamental ideas behind the new cultural activities in the area. Exploration of the potential of art and architecture is not simply meant to create places in harmony with the natural environment, but also to reconsider and discuss the conditions that ensure "well-being" —calling into question social systems, creatively exploring alternatives, and most importantly, looking for new ways of life.[3]

From this perspective, Lang/Baumann's decision to use inflatables here is not by chance. As already mentioned, inflatables recall the idea of radical new beginnings with hot air balloons, and are associated with social utopia.[4] They especially remind the viewer of utopian architectures and the search for imaginative new models of living and behavior: the creative forms of coexistence present in various

architectural plans and projects, such as those by Buckminster Fuller or the Paris group Utopie. There is also the example of Instant City on the coast of Ibiza in the early 1970s: a temporary and experimental inflated city, erected well away from an urban setting, it is reminiscent of the islands of the Seto Inland Sea.

Furthermore, inflated objects, their textures and shapes, are surely associated with the titles of the works. Although the forms, colors and the way they are installed vary according to each respective setting, all the works by Lang/Baumann that use these inflatable materials are titled *Comfort*, each with a different number. The meaning of the word "comfort" as "good feeling" or "ease" (noun), and "make to feel better" (verb) can easily be connected, for example, to the work *Comfort #2*, composed of a dozen inflated forms which appear to invite viewers to sit on them. However, the large bulky objects turn out to be very difficult to climb onto or to use in other ways. The outlines of these objects, although based on forms similar to letters are, when blown up, formless, indecipherable. Such "deceptive," "frustrating" or "non-sensical" kind of comfort can also be found in *Comfort #6* since the inside space of the building is so filled it is not only inaccessible but also impossible to view in its totality. Perhaps the bulky tubes covering the roof might provide extraterrestrials a cushion when they try to land on the earth!

One thing that is clear about Lang/Baumann's works is that they often evoke the perspectives of the stranger (from different space-time). For example, an oddly high, diving platform leaves—in our contemporary eyes —the question of its use. Regardless of the fact that it is based on a utilitarian object made with modern industrial material, it looks like the remains of a prehistoric time. In fact, their works skillfully and playfully suggest the possibility of alternative perspectives or "a stranger's eye," and force us to detach ourselves from familiar perceptions (by using well-known pictorial language) and create a moment of off balance. Unlike the "brutality of travel,"[5] the experience of momentary travels in our everyday life proposed by the works of Lang/Baumann bring real comfort. We are invited to encounter and to feel something beautiful and unknown, evoking philosophical thoughts and the contemplation of something seemingly essential.

1 The project was a part of *Fukutake House*. The name *Setouchi International Art Festival* was changed to Setouchi Triennale in 2013.
2 David Spalding, "It's Real. The Knowing, Dreaming Spectator," in: *L/B. I'm Real.* Exhibition catalogue, Galerie Urs Meile, Beijing-Lucerne. Beijing-Lucerne, 2009.
3 Editors' foreword, *Insular Insight-Where Art and Architecture Conspire with Nature*, Lars Müller Publishers, 2011. Edited by Lars Müller and Akiko Miki.
4 Philip Ursprung, "Comfort," *L/B BEAUTIFUL BOOK*, jrp|ringier, 2008.
5 Referring to the quote of Cesare Pavese at the beginning of the text. It is thought that the title of the book *The Comfort of Strangers*, by Ian MacEwan (1981), is derived from this phrase.

Concrete Science Fiction

Fabrice Stroun

In February 2012, I invited Sabina Lang and Daniel Baumann to design a temporary piece for the staircase of Kunsthalle Bern. Their ensuing wall work consisted of seven interwoven stripes painted in lime green, three shades of gray, pale blue and black, zigzagging from left to right, top to bottom, and across the ceiling. This painting profoundly modified the physical perception of the architectural space of the staircase, twisting lines of flight, as if adding speed to our eyesight.

Titled *Beautiful Walls #22*, this work was commissioned for an all-painting show. On the other side of the foyer, directly across the staircase, two 1965 canvases by Luigi Lurati hung one above the other. Lurati was one of the very first artists in Switzerland to treat geometric abstraction from the perspective of design, owing more to the graphic language of advertising than to the rarefied intellectual spheres of his Concrete forebears. Thinly painted and very much hand-produced, these works embody a fragile urgency, a do-it-yourself optimism that just about predates the industrialized "super-modern" aesthetics of the 1960s and 70s that Lang/Baumann hark back to. Separated by close to half-a-century, the space between the works of Luigi Lurati and Lang/Baumann could not be described as the distance between an (early, hopeful) model and its (late, nostalgic) copy. The resonance produced by this confrontation testified instead to a persistence of forms and effects that, while not unique to Switzerland, happens to be particularly charged in terms of ongoing local histories.

These narratives are made up of very individual artist's trajectories and of their passages through successive territories and reception contexts, rather than academies or "movements": that of Olivier Mosset, for example, who started in the mid-60s as a conceptual artist in the BMPT group in Paris, with clear affinities to both Pop and Minimal art, and whe

described his paintings at the time as arbitrary signs that aimed to perform the mechanics from which (all) paintings resulted. After he moved to the United States in the early Seventies, his work was first shown in a critical context focussing on the teleological endgame of monochromatic, "last" paintings, before these were considered as postscripts of History ('paintings of paintings'). Or of John Armleder's neo-Constructivist compositions, that were first understood as an erudite post-Fluxus gesture, before serving in the mid-80s as a standard for what would come to be called "Neo-Geo"—a term used to describe a wide range of practices that supposedly all entertained an ironic or allegorical relationship to abstract art of the past.

This history may at first seem only tangential to that of Lang/Baumann, who are not directly related to this trans-generational and transatlantic exchange that chiefly involves the object of painting. As Sabina Lang makes clear: "We looked at the time at Olivier Mosset and John Armleder as important figures, yet we never really considered either of them as painters." Nonetheless, it is important to acknowledge that their work appeared at the turn of the 1990s within a lively critical context centered on a number of young Swiss and American artists exhibiting in the region, who could all be considered as being primarily geometric abstract painters. These artists, like Francis Baudevin in Geneva, shared with Lang/Baumann a similar awareness that the repertoire of forms they were using had already cyclically traveled from the specialized field of art to the industrialized one of design, and back, a number of times. Outside of Switzerland, the work of Lang/Baumann participated in a more global critical displacement of forms and ideas coming from the various fields of design into the arena of art. Placing the viewer at the center of their project, their works at times questioned models of functionality and the limits within which an object can provide a service while continuing to symbolically function as art.

Coming back to the Kunsthalle show, their painting in the staircase functioned as a chute from the foyer to a section of the exhibition made up of pictures that act out the "intensity" of private relationships to fantasy worlds: Karen Kilimnik's English countryside, Andreas Dobler's Death Metal mountain higway or Vidya Gastaldon's psychedelic tea party. To my surprise, the chute worked both ways. While it brought down an anticipated intellectual detachment, it conversely carried atop the stairs a psychic disturbance that I originally thought to isolate. Today, as the work's historical contexts of emergence and reception (now over twenty years old) recede from view, what has never ceased to confound me is this capacity of Lang/Baumann's work to function as a porous membrane between fiction and reality. This is nowhere more evident than in the home/studio they built in a refurbished factory situated in the industrial outskirts of Burgdorf, half-an-hour away from Bern. Over two decades in the making, this *gesamtkunstwerk* is a living and working environment where every fixture has been designed and constructed by its inhabitants. Within it, all "artworks" stand on equal footing with purely functional, streamlined amenities. *Hotel Everland* (2002), for example, the nomadic hotel room which I first saw atop the Palais de Tokyo—offering two visitors a night an incomparable view of the Eiffel Tower—sits here on the roof of their factory, a few meters above their kitchen: a particularly comfortable guest room defined first and foremost by its usage. Simultaneously, far away from the sphere of cultural services that the art world has become since the 1990s, and seen against the bleak background of this small town's industrial zone, everything outside the perimeter of the building becomes positively otherworldly.
 One is in a spaceship,
 designed for autonomous living
 on alien grounds.
 This is still
 how the future feels.

A Poetic Insanity

Sue Williamson interviews Lang/Baumann

176

In the 21 years since Sabina Lang and Daniel Baumann first came together to form the artist partnership Lang/Baumann, the projects that L/B have taken on have grown increasingly ambitious and ever more wildly imaginative, yet underpinned always by expert planning. The early studio and performance work in alternative spaces has given way to museum shows and extraordinary interventions which radically alter urban and rural landscapes, or occupy the interior spaces of buildings in ways which often seem to promise access to a hidden world, an access which is ultimately denied. A football field is chalked with new curved white lines, but no rules exist for the game which the lines suggest. A road running between fields and painted in a brilliant geometric design leads… nowhere. A staircase that exits a tower room through the window returns the brave and curious walker back to the same place.

Drawing on early design and architectural training, L/B's solutions to artistic problems combine wit, powerful design, visual audacity and flawless construction.

SW Sabina, how and when did you and Daniel meet?
SL We first met in a cafe-bar in a squat house, Reithalle, in Bern, in 1989. Daniel was having a show in this place—large black and white photos—which impressed me a lot, so I looked out for the photographer.

At that time, Daniel was trained as a draughtsman, planning to study architecture and I had completed art school in Bern and became an apprentice as a window decorator. I only did this for one year and left then, because I had started to draw and paint.

Later we became a couple, and together we intensively discussed the question of how we could integrate art into our lives, become financially independent and "do things." Within the frame of this alternative scene it was possible for us to actually do so.

SW What was the first project or exhibition on which the two of you collaborated?
SL From the beginning, an important common interest was music and collaborating with musicians: most of our friends at that time were musicians, and we were giving performances with them or creating special illuminations for their experimental concerts. In most of our early shows, we integrated performances for which we utilized slide and overhead projectors, using liquids, paint, or soap to project colors and shadows; or we transformed record players, or worked with text.

In the frame of a culture exchange in 1991, we had the chance to exhibit together for the first time. For this show in a former gallery space in Leipzig, we had worked out quite a clear collaborative concept with individual works, and were a bit frustrated that visitors constantly wanted to divide our work by asking us who made what. From that moment we decided to work as a unit (inspired by artists like Fischli/Weiss and others) so as not to be disturbed by this annoying question of authorship again.

Shortly after this, we rented a studio in a small garage doing mainly painting, photography and screenprinting. To earn our living we worked in several jobs: me mainly in theaters as a technician, Daniel as freelance photographer for musicians, or both of us designing and screenprinting invitations and posters for others.

SW When did you decide to call yourselves Lang/Baumann?
SL At the time of our first show in 1991. From then on, we were Lang/Baumann.

SW From this point in the interview, I will address my questions to both you and Daniel.
Let's talk about one of your best known works, the unique one-room hotel unit which was located first at Lake Neuchâtel and then moved to Leipzig, from there to the roof of the Palais de Tokyo in Paris, and is now headed for the United States. Guests were permitted to stay for one night only in this extremely exclusive hotel—although they were allowed to steal the towels.
Of course, I am talking about the Hotel Everland. One guest wrote 'ENTER THE TIME WARP' in the Everland visitors' book. In its simplicity, that is quite an interesting statement about your work in general, even though it applies particularly to Everland. In Everland, once one closes the door to the outside, one is surrounded by curves and colors which echo back to an earlier period of design. The way in which that design mode is manifested down to the tiniest detail makes the experience of being in Everland supremely satisfactory. Once inside, one never wants to leave.
In many of your projects, the visitor is able to enter and be enclosed by a fantasy environment, which seems to exist purely for the pleasure of that one person. Design and art collide to provide a unique experience, sometimes in the most unlikely and unpromising spaces under a bridge in Buenos Aires, or on a street in Moscow, or in the small Swiss mountain village Vercorin.
Sometimes, like the engravings of the graphic artist, M.C. Escher, it describes an impossible reality. Was Escher an influence on your work in any way?

L/B For our *Beautiful Steps* series, Escher definitely is an influence. What we particularly like about his work is this incredible complexity of space you can enter with your eyes: recognizing everything immediately but still constantly searching for the key, the dilemma between what you see and what you know. Another point is that you always have different views in his drawings that are fully true if you look at each one, isolated from the others. It is only the combination of them that creates an unworkable image. What one can learn from Escher is that there are circumstances where truth + truth ≠ truth

SW I have always particularly liked the *Beautiful Steps* series. In daily life, staircases are a supremely logical architecture feature of any building of more than one story. One uses them to ascend or descend from one level to another. But your staircases deny us this possibility.
There is one that impudently sits high up on two facets of the concrete side of a classic modernistic skyscraper in Biel-Bienne. This staircase connects two steel doors, one at the top and one lower down, around the corner, as if there is some sort of private and illegal dwelling that has somehow inserted itself into the façade. How did that commission come your way?

L/B This work was our contribution to the 11th Swiss Sculpture Exhibition that took place in the city of Biel-Bienne in 2009. *Utopics*, curated by Simon Lamunière,

included fifty artworks dealing with the themes of utopia, micro-nations, territories and the "urban situation."

We chose the Convention Center, built in 1966, as a site of intervention because this building had intrigued us for a long time. As the only tall building in the city's center it is a statement in itself, but also the architectural details—besides its general beauty—are highly fascinating. First of all, the glass faade contains an illusion: the grid of windows does not correlate with the number of floors. In fact, there are several rows of windows to each floor. That's why the building appears to be much higher than it is. Fifty-five meters is not that high for a skyscraper.

Secondly, a frame-like concrete structure is inset asymmetrically into the steel, glass tower. This structure sections the building on one side and forms a massive, empty concrete wall standing next to the tower on the other side. Our idea was to work on this wall.

We made *Beautiful Steps #2*, a metal stairway that connects one fake door with another around the corner. It was all done in about a twenty percent smaller scale than real, to keep the optical illusion of the building's size.

At the same time we tried to design it so that it would match the building perfectly, and placed it precisely between two of the visible horizontal joints of the concrete. With the choice of the material and the simple design, we wanted to give the impression that it might even be a real access that is in use for technical reasons. It should be visible and recognizable but at the same time it should be fragile and elegant. So it's kind of having a presence of being logically self-evident and poetically insane at the same time.

SW Was the architect of the building receptive to your intervention?

L/B The architect Max Schlup (1917–2013), a member of the School of Solothurn, a Swiss postwar architectural movement, was contacted by the city of Biel to ask about his acceptance, as they wanted to acquire the work as a permanent piece for the collection. In fact, he did not like it at all, which was a hard one for us to take, because we really thought we had worked in a very respectful way. But at the same time we think that from his perspective it was his right not to like it. Humor and Modernism are sometimes not best friends.

SW I am glad that in this case, the city decided in favor of humor and the steps are still in place.

There is another delicate clash between Humor and Modernism in the title of your book, *More is More*, which not only sets on its head the über Modernist Mies van der Rohe's famous aphorism that less is more, but says it twice over from two positions. This is, in effect, a direct challenge to the pared down aesthetic of modernism, declaring it to be outdated. Or at least, demanding that space be made for a very different aesthetic, an ebullient, colorful, playful art such as yours, in which the clean lines of architecture are often disrupted by inflated tubes which escape from windows, wrap roofs, or fall down the sides of a building like out of control entrails.

What is your interpretation of your title, *More is More*, and why did you choose it?

L/B We like this statement a lot! We came across it some years ago. We actually don't believe the "Less is More" dogma can be imposed on modernist architecture in general. Looking at architects like Oscar Niemeyer or Eero Saarinen, one could better describe their work as "more is more." But of course, the reality is not black or white. At which moment more is required and when less is appropriate, has to be considered constantly during a work process.

The main reason for choosing this title for the book was the concept of the mirrored image pages. This offers a second view of each image, maybe lets you question what you see, but of course gives a plus by creating one new image with the two of them. It was interesting for us to see how the space expanded and changed into a new space.

> SW I think many artists might not have allowed this deliberate duplication of the image of their work, feeling that a book should present an artwork exactly as it existed in reality. You, however, in some cases, have even set works on their sides in the book, and mirrored them this way.

L/B In fact, when the graphic designers first came up with the idea of the mirrored images, we were skeptical about showing our work in this way. But then we noticed that this is actually a logical continuation of a duality we work with anyway: the simultaneity of true and false.

> SW Your design background has clearly given you a daring perspective that permits this freedom, a freedom that is exercised in the way you work. One of your key tropes, the steps, can be as simple as a pair of ladders ascending into an attic, or as elaborate as a curving staircase suspended in the beautiful baroque interior of Schloss Trautenfels, Austria, as in *Beautiful Steps #3* (2010). Like many of your works, the conception and construction of this staircase required a consideration of space, a remarkable architectural sophistication and an acute knowledge of fabrication which is clearly a product of Daniel's architectural training.
>
> But beyond the technical aspects of this last piece, there is, again, the fantasy element: the impossible staircase that must be climbed to reach the fairy princess…

> Were fairy tales in your minds at all when you conceived these works? Or where did the fascination with stairs arise?

L/B The decision to start working with stairs came as a result of engaging with functionality in our works for the past years. One of our first really functional projects was *Infomobile* (1999) for Kunsthalle Bern: three furniture-like, carpet-cladded wagons containing seating, library and mini-bar. From that point on we started offering a physical interaction between the observer and the work. Our main interest was to let the viewer first forget about distance in perception, and only later, when already enclosed by or busy "using" the work, consider the question of distance and of one's own role inside this constellation.

Later, this brought us to a more abstract exposure by dealing with a pseudo-functionality, stopping at the moment one would try to use the work, like *Diving Platform* (2005) which has an inaccessible ladder starting only high above the ground. So here we found something that attracted us: the possibility to play with function as an easy-to-read code, but by twisting something—either the context, the scale or a static element—questioning it.

When peeling the real function off the form and showing the inoperable function as form influenced by a potential functionality as we know it, the real beauty of function becomes apparent. This condensation is very present in the shape of stairs. What we particularly like is that, as you mention, the stairs are always identifiable as stairs even if formally extremely reduced. They are signs: modular, complex and simple constructions and they talk about the scale of the human body and movement, as in *Nude Descending a Staircase* by Duchamp.

At the start of working on a new project we have dream-like images in our heads, rather than a fairytale. Even if we have stories we do not want to tell them right away, we want to keep this space as open as possible

Such an image consists of a shape in contrast or connection with the surroundings and our focus is how to fit the work perfectly to the site.

SW Let's talk a little bit about the materials you use to make the work fit perfectly to the site. Your vocabulary includes surfaces painted in brilliant geometric designs, fluorescent lighting tubes wrapped in color and arranged in curving screens, outsize soft vinyl tubes inflated to disguise or perhaps highlight architectural features, interiors that are carpet cladded, staircases in steel or concrete… Are there new materials you would like to try but haven't yet had the opportunity—or perhaps the right site—to use?

L/B We see material as something that is determined by the situation and the form or object we want to create. Of course this does not mean that we do not like material, but we hardly ever say "Let's make a wood/concrete sculpture and see where we can place it."

If we use a material it often has a reason besides the way it looks. For instance, carpet has an impact on acoustics, wood or aluminum are lightweight, wood is easy to construct with, metal is strong, etc. Lately, we're using plainer, simpler material like wood, different sorts of metal like aluminum, copper, brass, steel, or we work with concrete. Even for the inflatables we started with colorful foils and now use either transparent, or white or metallic material.

For *Beautiful Steps #7*, a new work we are doing for Lyon, we will use Ultra-High Performance Fibre Reinforced Concrete (UHPFRC) for the first time, due to the necessity for absolute stability. The permanent stair-shaped sculpture will be installed directly on the riverbank of the Saône, overhanging the bank quite dramatically. People will be able to step up and enjoy the view over the river from a small stage forming the end of the staircase.

The new technology of this superior kind of concrete allowed the combination of an elegant, thin shape with tremendous strength for the cantilevered construction. During the process it required a complicated calculation by engineers, including specialists of the Federal Polytechnic School EPFL in Lausanne.

But to us, both approaches are interesting: to work with new challenging materials and to collaborate with specialized people, or to work with materials we know extremely well and that are easy for us to handle, like the wall paintings we do with simple flat paint.

An idea we have had in mind for a while and have not yet had the possibility to realize is more related to a site than to a material: making a space or small building that would rotate…

SW I feel sure the opportunity will arise before too much longer. These days, you are in the enviable position of being able to pick and choose amongst numerous requests to undertake a beautiful new project in a yet unvisited corner of the world. Which sites will you be working on next?

L/B Besides the work for Lyon, we have just finished a work (*Spiral #3*) on a disused funicular in Valparaiso, Chile—a great place to work in public space.

SW I will look forward to enjoying the images on your website www.langbaumann.com, and hopefully also being able to visit some of your latest projects! Thank you.

Drawings

Title:	Comfort #12
Technique:	Polyester fabric, ventilator
Dimensions:	28 tubes between 10 and 45 m length, diameter 1 m
Solo show:	2013, "Struktur und Zufall", Wilhelm Hack Museum, Ludwigshafen D

The exhibition space on the ground floor of the museum has several levels linked by various steps. For the exhibition, all removable partitions were taken down. Cleared of visual distractions, the space readily revealed its open structure and the architectural idea behind it. Seven groups of four parallel, inflatable tubes sliced through the exhibition space in different ways and directions. Each group of tubes began at a particular starting point, e.g. the top of a wall, and ran in a straight line along floor, walls, ceiling, up and down steps—roughly tracing the contours of the space it traversed. Imagined as an independent structure outside the space, the tube sculpture might read like an extra large and very rough sketch of the interior.

Comfort #12

0 1 2 m

Title:	Beautiful Wall #29
Technique:	Wall painting
Dimensions:	14.1 × 4.1 m
Solo show:	2013, "Struktur und Zufall" Wilhelm Hack Museum, Ludwigshafen D

A fabric of horizontals and intersecting diagonals made its way across the entire wall from top right to bottom left, with a concentration of lines in the middle. Saturated reds, yellowish orange, pink, gray, and black contrasted with the white wall and radiated into the room.

Beautiful Wall #29

1 2 m

title: Beautiful Wall #28
technique: Wall painting
dimensions: 18.4 × 10.4 m
solo show: 2013, "Struktur und Zufall," Wilhelm Hack Museum, Ludwigshafen D

An intersecting jumble of gigantic, gray, black and colored zigzag lines spread across the back wall of the exhibition space. Tapering, stretching, and set off against the white wall, the lines generated an impression of three dimensionality. However, in order to see the picture in its entirety, viewers had to stand directly in front of it, which distorted the view while, from farther away, the view was obstructed by architectural modifications and the installation, *Comfort #12*.

Beautiful Wall #28

Title:	Beautiful Wall #27	The painting drew attention to a wall that is merely meant to screen the stairs off from the exhibition space in the museum. Broad, parallel diagonals emerged from the sides, forming an oscillating pattern of endless loops and parallel bands of color in azure blue, purple, greenish yellow, gray and black.
Technique:	Wall painting	
Dimensions:	9.3 × 5.7 m	
Solo show:	2013, "Struktur und Zufall," Wilhelm Hack Museum, Ludwigshafen D	

188

Beautiful Wall #27

title:	Spiral #3
technique:	Wood, paint
dimensions:	3.6 × 3.6 × 18 m
group show:	2013, "Of Bridges & Borders," Monjas, Valparaiso CL

The temporary intervention, mounted on the tracks of a funicular that had been closed down a few years earlier, consisted of a geometric structure of white painted wood, twisting up the mountain like a rectangular spiral. Visible from afar, the sculpture echoed the movement of the carriages that used to travel up and down.

Residents of the neighborhood embraced the work as a welcome symbol of their efforts to reinstate the funicular.

Spiral #3

0 10 20 m

The entire floor, lateral wall, and ceiling of the 300 m long visitor corridor are painted. The geometry of the painting is based on seven different quadrilaterals of equal size, ranging from narrow vertical shapes, by way of some squat—almost square—shapes, to narrow horizontal strips. Each of these near-rectangles is used several times in a variety of sequences. Three sides of each shape are aligned at right angles, while the fourth side is off by two percent. As the shapes are lined up—groups of verticals alternating with sections of horizontals—this slight irregularity creates a ripple effect with an undulating movement along the entire length of the wall. Sections of mostly vertical forms look crowded or condensed, while strings of horizontals appear empty.

Title: Beautiful Walls #25
Technique: Polyurethane coating
Dimensions: 3.5 × 3.8 × 300 m
Site: KVA Energiezentrale Forsthaus, Bern CH
Commission: 2013, ewb

190

Beautiful Wall #25

Comfort #4

Title:	Comfort #4
Technique:	PVC-foil, tubes, ventilator, light
Dimensions:	53 × 3.5 × 2 m
Group show:	2012, "Glow" de Bijenkorf, Eindhoven NL

Inflated white tubes connected all 36 openings in the top part of a ceramic facade that actually extends above the roof of the building behind it. Each section of tube was randomly threaded through several openings, creating a huge string of knots tied across the entire facade. At night, lights from behind cast a bright glow through the translucent foil.

191

Title:	Beautiful Wall #23
Technique:	Wall painting
Dimensions:	3.1 × 21.25 m
Site:	Swiss National Bank, Zürich CH
Commission:	2012, SNB

A vertically aligned pattern of stripes in three colors and four shades of gray covers an entire wall of a very tall stairwell. The vertical accent underscores the dramatic dimension of this space. Depending on the position and perspective of the viewer and the quality of the light, the experience of the work varies considerably. As a rule one sees either a small section or else a strongly distorted view of the whole.

Beautiful Wall #23

title:	Beautiful Steps #9
Technique:	Stainless steel, lacquer
Dimensions:	2.5 × 3.7 × 3.5 m
Site:	Vaudoise, Lausanne CH
Commission:	2012, Vaudoise Assurance

A fragment of an impossibly twisted circular stair rises from the ground and leads nowhere. While invisibly anchored in the ground, the sculpture inexplicably stands upright on its own. The first step is horizontal and parallel to the ground, but with each successive step the stair torques away from its original axis by 5 degrees until it projects into space at a steep angle. Adding to the drama, a continuous reduction in riser height emphasizes the foreshortening of the sculpture towards the top.

Beautiful Steps #9

Title:	Comfort #11
Technique:	PVC-foil, ventilator, LED light
Dimensions:	4 tubes of 12 m length, diameter 1.15 m each
Group show:	2012, "Smart Illumination Yokohama 2012" Zou-no-hana Port of Yokohama, Yokohama JP

Several fully inflated white tubes were squeezed into the back of a small boat. Each tube was equipped with an interior light source. At night, the boat cruised the harbor and occasionally took passengers along for a ride. Gliding across the black waters with its spray of glowing tubes, the boat offered a surreal image.

194 Comfort #11

Title:	Open
Technique:	Wood, lacquer
Dimensions:	11.3 × 5.3 × 5.8 m
Solo show:	2012, "Open" Grand Palais, Bern CH

The focus of this installation was on the building itself: tunnel-like passages created by connecting pairs of doors and windows turned the building inside out. The passages could be traversed or simply looked through. The "perforated" building was thus transformed into a permanently accessible sculpture.

Open

195

Title:	Street Painting #3
Technique:	Road marking paint
Dimensions:	171×3.5 m
Site:	Fussgänger- und Velo Unterführung Ulmbergtunnel, Zürich CH
Commission:	2012, City of Zürich

This public art project was commissioned by the City of Zurich for the renovation of the Ulmbergtunnel underpass. Based on the center line that divides the path between pedestrians and cyclists, a floor painting composed of overlapping straight and curved pathways of color extends the entire length of the underpass. Painted dark gray, gray, white, and magenta, each shape measures 1/4 of the width of the tunnel and is framed by a yellow line.

196 Street Painting #3

Title: Beautiful Walls #22
Technique: Wall painting
Dimensions: ca. 4 × 18 m
Group show: 2012, "The Old, the New, the Different" Kunsthalle, Bern CH

Painted ribbons of color—lime green, pale blue, deep black in one and three shades of gray in another—rose up the walls and across the ceiling of the stairwell. Cued by three imaginary diagonals, the ribbons tapered, widened, and changed direction. Moreover, the two strands of the painting crossed at several points, adding a sculptural dimension to an essentially flat work: as a result the stairwell, all but unnoticed under normal conditions, suddenly emerged as a space apart.

Beautiful Walls #22

0 1 5 m

Title:	Comfort #6
Technique:	Polyester fabric, ventilator
Dimensions:	5 tubes of 35 m length each, diameter 2 m
Solo show:	2011, "Comfort #6" Fri-Art Centre d'Art Contemporain, Fribourg CH

The old city of Fribourg sits on a peninsula with steep slopes; the Kunsthalle is not in the city center but below it. The installation consisted of five golden inflated tubes draped over the roof of the Kunsthalle building. By increasing the visibility of the building from the city center, the installation highlighted the Kunsthalle's importance for the city. The air-filled tubes literally insulated the building like a protective layer while making it stand out from its surroundings.

198 Comfort #6

Title:	Beautiful Tube
Technique:	Wood, carpet, lacquer
Dimensions:	2 segments of 10 × 4 × 2.4 m / 18 × 4 × 2.4 m
Commission:	2011, "Beautiful Tube" Wroclaw Contemporary Museum, Wroclaw PL

Beautiful Tube was conceived as a contrast to the architecture of the museum's galleries. The museum occupies a repurposed bunker from World War II. This permanent installation occupies two segments of the ring-shaped museum lobby. Covered on all sides (floor, ceiling, walls) with rectangular cuboids of varying dimensions, the two spaces look like tunnels of a sort. The surfaces of the cuboids are alternately painted with colored laquer or encased in carpet, altering the visual and acoustical experience of the space. The installation serves as a venue for small events and provides museum visitors with a place to sit and read.

Beautiful Tube

199

10 m
5
0

Title: Street Painting #6
Technique: Road marking paint
Dimensions: 28 × 8 m
Solo show: 2011, Strelka Institute of Media, Design and Architecture, Moscow RU

Executed on the pavement in front of the entrance of the Strelka Institute, the parallel stripes of the painting lined up with the sidewalk and tapered towards the river. With this built-in distortion the painting and its shape changed considerably depending on the perspective of the viewer, say from the roof terrace of the Strelka or from the bridge on the opposite side.

200 Street Painting #6

0 1 5 m

Title:	Beautiful Steps #8
Technique:	Wood, lacquer
Dimensions:	height 3.1 m, diameter 2.5 m
Solo show:	2011, Galerie Loevenbruck, Paris F

A winding stair, slightly askew, was mounted between floor and ceiling of the gallery. Somewhat smaller in scale than an actual stair, the functional aspect of the sculpture was further diminished. This modular piece can be adjusted to different ceiling heights by adding or subtracting steps.

Beautiful Steps #8

5 m

1

0

Title: Beautiful Entrance #6
Technique: Concrete relief
Dimensions: 31.2 × 1.7 m
Site: Freibad zwischen den Hölzern, Zürich CH
Commission: 2011, City of Zürich

Developed for the renovation of a public outdoor swimming pool in Zurich, this concrete relief replaces a row of planters that formerly marked the end of the platform inside the facility. At the same time it adds character to the pool entrance and puts a new face on the forecourt. The wall consists of 11 prefabricated concrete elements that form a three-dimensional pattern of curved ribbons.

202

Beautiful Entrance # 6

Title:	Beautiful Bridge #1
Technique:	Flat paint
Dimensions:	68 × 10 m
Group show:	2011, "Of Bridges & Borders" Puente Figueroa Alcorta, Recoleta, Buenos Aires AR

This pedestrian overpass in the lively Recoleta neighborhood of Buenos Aires was built in the 1960s. It is an elegant construction in concrete, painted white, and its convex underside offered an intriguing canvas for a painting. A broad pattern of overlapping stripes in black and different pastel shades of color was applied to the concrete surface. Because of the arched and convex underside of the bridge, the strictly geometrical pattern appeared strangely distorted from different perspectives.

Beautiful Bridge #1

203

Title:	Beautiful Steps #6
Technique:	Wood, paint
Dimensions:	5 × 2.8 × 5.8 m
Group show:	2011, "Of Bridges & Borders" Fundacion Proa, Buenos Aires AR

A stair sculpture was installed in the atrium that connects the museum's upper gallery with the bookstore. This unlikely hybrid between a straight and a curved stair hung freely in space. Slightly smaller in scale than a real set of stairs, the sculpture developed a very different dynamic depending on the perspective of the visitor: viewed from above it exerted a downward pull, seen from below it appeared to be floating in space.

204

Beautiful Steps #6

Comfort #4

Title: Comfort #4
Technique: PVC-foil, tubes, ventilator, light
Dimensions: 9 tubes between 50 and 67 m length, diameter 0.95 m
Group show: 2010, "Nuit Blanche" Ecole Elementaire de Belleville, Paris F

Two rows of windows of a neighborhood elementary school connected by a tangle of inflated white tubes for one White Parisian Night. Shorter sections of tube had been randomly threaded in and out of the windows, producing what looked like a huge string of knots. After dark, the installation radiated a soft glow as the light from the building illuminated the translucent foil from the inside.

205

Title:	Street Painting #5
Technique:	Road marking paint
Dimensions:	100 × 60 m
Solo show:	2010, "R-Art" Vercorin CH

Every year the mountain village of Vercorin invites an artist to create a work that engages with the local situation and will grace the village during the summer months. From the village square, surrounded by densely packed old Valais-style wooden houses, this street painting extended along the five streets that lead away from the center. Painted directly onto the pavement, the work unfolded in an intricate pattern of wide ribbons of bright color that contrasted cheerfully with the muted character of wood and stone, the village's predominant materials.

206 Street Painting #5

Title: Comfort #8
Technique: Polyester fabric, ventilator
Dimensions: 36 × 2.1 × 0.3 m
Solo show: 2010, Galeria Foksal, Warsaw PL

This site-specific project, circumscribed by the architecture and tradition of Galeria Foksal, represented a sort of homage to a space that had been a center of the Polish avant-garde in the sixties and continues to function as an artist-run space to this day. Seven parallel air-filled tubes installed along the walls of the gallery traced the outline of the space and reproduced its contours. The soft and bulging textile surface of the walls and the glow of the color gold transformed the visitor's sense of the space by distorting the dimensions and acoustics of this storied gallery.

Comfort #8

207

Title:	Comfort #6
Technique:	Polyester fabric, ventilator
Dimensions:	5 tubes between 39 and 55 m length, diameter 2 m
Group show:	2010, "Fukutake House" Art Setouchi 2010, Megijima, Kagawa JP

The island groups of the Seto Inland Sea (Kagawa Prefecture) are increasingly marked by depopulation. For this exhibition several vacant buildings were selected as installation sites. The roof of an abandoned kindergarden on the small island of Megijima was wrapped in five giant inflatable tubes. From inside the building the tubes emerged through a row of windows just below the eaves, folded back over the roof, and disappeared inside again through the windows at the back.

208 Comfort #6

Title:	Beautiful Steps #5
Technique:	Laminated wood, paint
Dimensions:	width of the step 0.7 m, height 1.1 m, diameter 8 m
Group show:	2010, "10th Regionale. Fabricators of the World. Scenarios of Self-will" Schloss Trautenfels, Trautenfels A

Two curved stairs ascended to two windows at right angles. Outside each window a curved walkway projected into the air and disappeared in a loop around the facade of the building. Viewed from the outside, the walkway could be seen to connect the two windows like a fragile band around the castle's corner tower. Interior and exterior elements of the scultpture formed a complete circle.

Beautiful Steps #5

Title:	Beautiful Steps #3
Technique:	Wood, paint
Dimensions:	11.5 × 5 × 4.3 m
Group show:	2010, "10th Regionale. Fabricators of the World. Scenarios of Self-will" Schloss Trautenfels, Trautenfels A

A white, curved stair, slightly askew and suspended in midair in a baroque castle hall, was held aloft by a few slender, almost invisible cables. The lean shape and the white surface of the sculpture formed a striking contrast to the lush frescoes on the ceiling.

Beautiful Steps #3

Title: Beautiful Walls #18
Technique: Wall painting
Dimensions: 28.4 × 5.2 m
Group show: 2009, "Portrait de l'artiste en motocycliste. Olivier Mosset" Magasin, Grenoble F

A long wall consisting of a straight and a curved section. Unfolding from a dense center near the intersection of the two, the painting, a linear pattern of broad stripes —gray, black, light green, salmon, and yellow—extended in all directions.

Beautiful Walls #18

211

Title: Der vierte Steg
Technique: Steel, concrete
Dimensions: 6.7 × 1.3 × 2.6 m
Site: Bahnhof, Bolligen CH
Commission: 2009, Canton of Bern

This public art project adds a footbridge to three newly installed links across the small river between train station platform and bus stop. But instead of a straight and level surface to get across, the footbridge features a descending set of stairs on either side, connected by a small platform close to the surface of the water for an alternative if somewhat irritating crossing.

212 **Der vierte Steg**

Title: Perfect #4
Technique: Acrylic glass modules, lacquer
Dimensions: 12 × 2.7 × 0.25 m
Solo show: 2009, "Le Bel Accident. Vincent Ganivet, Lang/Baumann", Le Confort Moderne, Poitiers F

Each asymmetrically-shaped module evokes a stylized wave. Arrayed in long staggered rows they formed three concave bodies with smooth shiny surfaces that reflected the light and rendered a distorted mirror image of the surrounding space.

Perfect #4

213

Title:	Beautiful Steps #4
Technique:	Wood, paint
Dimensions:	7.2 × 7.2 × 5.1 m
Solo show:	2009, "Le Bel Accident. Vincent Ganivet, Lang/Baumann" Le Confort Moderne, Poitiers F

A giant white spiral stairway suspended from the metal construction that supported the industrial glass roof of the exhibition space. Slightly lopsided and appearing to float in space, the sculpture was held aloft by several slender cables. Viewed from a hypothetical point straight up, the spiral would be seen to form an almost full circle.

214 Beautiful Steps #4

0 5 10 m

Title:	Beautiful Steps #2
Technique:	Zincked steel, anodized aluminium
Dimensions:	1.77 × 5.23 × 4.58 m
Group show:	2009, "Utopics. 11th Swiss Sculpture Exhibition" Biel-Bienne CH
Collection:	Kunstsammlung der Stadt Biel-Bienne CH

The congress building in Biel-Bienne plays a trick on perception: because the diminutive grid of its large glass front does not match the ceiling height of the floors, the building appears taller than it is—more like a skyscraper than its actual 50 meters (164 foot) of height. The building also features an unusual concrete structure that encloses one half of the volume like an oversize frame, leaving a gap on one side between itself and the building. On this pillar, almost three-quarters of the way up, an aluminum stair was attached, leading from one fake door to another around one corner of the structure. In keeping with the optical illusion of the building, the work was built to a slightly smaller scale than a normal door and stair. The slender sculpture plays with an imaginary functionality.

Beautiful Steps #2

Title: Spielfeld #4
Technique: Paint
Dimensions: 21.5 × 44.5 m
Group show: 2009, "Acte3 Aravis" Patinoire, La Clusaz F

The concrete floor of the village skating rink was painted with wide looping ribbons of primary colors evocative of the swooshes and curves carved by skaters on ice. The painting was then iced over and served as a visual background to a winter season of skating and hockey playing.

216 Spielfeld #4

Title: Flash #2
Technique: 59 barber poles
Dimensions: 2.3 × 6.4 × 9.3 m
Solo show: 2009, "I'm Real" Galerie Urs Meile, Beijing PRC

This installation, comprised of 59 custom-made barber poles arranged in a circular configuration of swirling green and silver bands, curls open at one end to admit visitors into its vertiginous center. Spinning in unison and lit from within, the poles form a curving wall that nearly encloses the viewer: once in its epicenter, the visitor is caught up in a dizzying and hypnotic optical experience that begins to impact the body's equilibrium. The modular installation can be adjusted to different configurations of space.

Flash #2

217

Title:	Beautiful Carpet #1
Technique:	Carpet
Dimensions:	4.8 × 6.8 m
Solo show:	2009, "I'm Real" Galerie Urs Meile, Beijing PRC

A carpet with a multicolor pattern of wide stripes covered one part of the gallery floor. The surface of the carpet was very soft and the pile along the edge of the stripes cut slightly shorter. This lent the carpet a three-dimensional feel.

Beautiful Carpet #1

Works

2013
2012

Comfort #12
Polyester fabric, ventilator
28 tubes between 10 and 45 m length,
diameter 100 cm
2013, "Struktur und Zufall"
Wilhelm Hack Museum,
Ludwigshafen D

Beautiful Wall #29
Wall painting
14.1 × 4.1 m
2013, "Struktur und Zufall"
Wilhelm Hack Museum,
Ludwigshafen D

Beautiful Wall #28
Wall painting
18.4 × 10.4 m
2013, "Struktur und Zufall,"
Wilhelm Hack Museum,
Ludwigshafen D

Beautiful Wall #27
Wall painting
9.3 × 5.7 m
2013, "Struktur und Zufall"
Wilhelm Hack Museum,
Ludwigshafen D

Beautiful Wall #25
Polyurethane coating
3.5 × 3.8 × 300 m
2013, KVA Energiezentrale Forsthaus,
Bern CH

Spiral #3
Wood
3.6 × 3.6 × 18 m
2013, "Of Bridges & Borders"
Valparaiso, Chile CL

Beautiful Wall #23
Wall painting
3.1 × 21.25 m
2012, SNB, Zürich CH

Beautiful Steps #9
Stainless steel, lacquer
2.5 × 3.7 × 3.5 m
2012, Vaudoise, Lausanne CH

Comfort #4
PVC-foil, tubes, ventilator, light
53 × 3.5 × 2 m
2012, "Glow"
de Bijenkorf, Eindhoven NL

Comfort #11
PVC-foil, ventilator, LED light
4 tubes of 12 m length,
diameter 115 cm each
2012, "Smart Illumination Yokohama
2012" Zou-no-hana / Port of Yokohama,
Yokohama JP

Street Painting #3
Road marking paint
171 × 3.5 m
2012, Ulmbergtunnel, Zürich CH
Commissioned by
the city of Zurich

Beautiful Walls #22
Wall painting
ca. 4 × 18 m
2012, "The Old, the New, the Different"
Kunsthalle, Bern CH

222

2012
2011

Open
Wood, lacquer
11.3 × 5.3 × 5.8 m
2012, "Open"
Grand Palais, Bern CH

Comfort #6
Polyester fabric, ventilator
5 tubes of 35 m length each, diameter 200 cm
2011, "Comfort #6" Fri-Art Centre d'Art Contemporain, Fribourg CH

Beautiful Entrance #6
Concrete relief
31.2 × 1.7 m
2011, Freibad zwischen den Hölzern, Zürich CH

Comfort #4
PVC-foil, ventilator
several tubes of 60 m length each, diameter 95 cm
2011, "Môtiers 2011. Art en plein Air", Môtiers CH

Comfort #10
Polyurethane-foil, tubes, ventilator
500 × 330 (ø) cm
2011, "Höhenrausch 2. Luftsprünge & Wasserspiele"
OK Offenes Kulturhaus, Linz A

Shine #3, #2
Aluminium anodized
50 × 50 × 8 cm
2012, Multiple 1/5 - 5/5, Edition 5, Erstfeld CH

Beautiful Tube
Wood, carpet, lacquer
2 segments of
10 × 4 × 2.4 m / 18 × 4 × 2.4 m
2011, Wroclaw Contemporary Museum, Wroclaw PL

Wave #2
Aluminium, lacquer
184 × 40 × 29.7 cm
2011, Galerie Loevenbruck, Paris F

Street Painting #6
Road marking paint
28 × 8 m
2011, Strelka Institute of Media, Design and Architecture, Moscow RU

Beautiful Walls #20
Wall painting
2.70 × 38 m
2011, Homburger Collection, Prime Tower, Zürich CH

Beautiful Steps #8
Wood, lacquer
height 310 cm, diameter 250 cm
2011, Galerie Loevenbruck, Paris F

223

2011
2010

Beautiful Bridge #1
Flat paint
68 × 10 m
2011, "Of Bridges & Borders"
Puente Figueroa Alcorta, Recoleta,
Buenos Aires AR

Beautiful Steps #6
Wood, paint
5 × 2.8 × 5.8 m
2011, "Of Bridges & Borders"
Fundacion Proa, Buenos Aires AR

Comfort #4
PVC-foil, tubes, ventilator, light
9 tubes between 50 and 67 m length,
diameter 95 cm
2010, "Nuit Blanche"
Ecole Elementaire de Belleville,
Paris F

Golden Table #2
Wood, brass
120 × 300 × 90 cm
2011, Kultur- und Kongresszentrum,
Thun CH

Comfort #6
Polyester fabric, ventilator
5 tubes between 39 and 55 m length,
diameter 200 cm
2010, "Fukutake House"
Art Setouchi 2010,
Megijima, Kagawa JP

Street Painting #5
Road marking paint
100 × 60 m
2010, R-Art, Vercorin CH

Spirals #2
Copper, varnish
140 × 50 × 25 cm
2010

Beautiful Steps #5
Laminated wood, paint
width of the step 70 cm, height 110
cm, diameter 8 m
2010, "10th Regionale.
Fabricators of the World.
Scenarios of Self-will"
Schloss Trautenfels, Trautenfels A

Beautiful Steps #3
Wood, paint
11.5 × 5 × 4.3 m
2010, "10th Regionale.
Fabricators of the World.
Scenarios of Self-will"
Schloss Trautenfels, Trautenfels A

Tubes #12
aluminium anodized,
polyurethane glue
100 × 255 cm (100 × 125 cm each)
2010

Street Painting #4
Road marking paint
Concept
2010, "Biennale de Belleville"
Quartier de Belleville, Paris F

224

2010
2009

Comfort #8
Polyester fabric, ventilator
36 × 2.1 × 0.3 m
2010, Galeria Foksal, Warsaw PL

Beautiful Floor #1
Styrofoam aluminium epoxy boards, PU lacquer
500 × 400 cm
2009, Haus Nyffeler, Erstfeld CH

Flash #2
59 barber poles
230 × 640 × 930 cm
2009, "I'm Real"
Galerie Urs Meile, Beijing PRC

Spielfeld #5
Aluminium soccer goals, styrofoam, sand
2 × 3 × 25 m
2009, WolaArt, Warsaw PL

Beautiful Steps #4
Wood, paint
7.2 × 7.2 × 5.1 m
2009, "Le Bel Accident. Vincent Ganivet, Lang/Baumann"
Le Confort Moderne, Poitiers F

Spielfeld #4
Paint
21.5 × 44.5 m
2009, "Acte3 Aravis"
Patinoire, La Clusaz F

Beautiful Walls #18
Wall painting
28.4 × 5.2 m
2009, "Portrait de l'artiste en motocycliste. Olivier Mosset"
Magasin, Grenoble F

Perfect #4
Acrylic glass modules, lacquer
12 × 2.7 × 0.25 m
2009, "Le Bel Accident. Vincent Ganivet, Lang/Baumann"
Le Confort Moderne, Poitiers F

Der vierte Steg
Steel, concrete
6.7 × 1.3 × 2.6 m
2009, Bahnhof, Bolligen CH
Commissioned by the canton of Bern

Beautiful Steps #3
Wood, paint
11.5 × 5 × 4.3 m
2009, "Le Bel Accident. Vincent Ganivet, Lang/Baumann"
Le Confort Moderne, Poitiers F

Beautiful Steps #2
Zincked steel, anodized aluminium
177 × 523 × 458 cm
2009, "Utopics. 11th Swiss Sculpture Exhibition"
Art in urban space, Biel-Bienne CH

225

2009
2008
2007

Beautiful Carpet #1
Carpet
4.8 × 6.8 m
2009, "I'm Real"
Galerie Urs Meile, Beijing PRC

Perfect #5
Plastic modules, lamps, metal construction, lacquer
370 × 130 × 200 cm, 150 × 120 × 200 cm, 160 × 95 × 200 cm, 130 × 120 × 200 cm
2008, "more is more"
Galerie Loevenbruck, Paris F

Diving Platform *(2005)
Steel, fiberglass, lacquer, diving board
4 × 1.8 × 13 m
2007, "Môtiers 2007. Art en plein Air",
Môtiers CH

Comfort #6
Polyester fabric, ventilator
5 tubes between 39 and 55 m length,
diameter 200 cm
2008, "La noche en blanco"
Fundacion Telefónica, Madrid ES

Spielfeld #3
Epoxy paint, metal, lacquer
5.8 × 13 m
2008, "Balls and Brains"
Helmhaus, Zürich CH

Tubes #2
Aluminium tubes, anodized
4.8 × 3.5 m
2008, Voltashow,
Galerie Loevenbruck, Basel CH

Comfort #4
PVC-foil, ventilator
1 tube of 60 m, diameter 95 cm
2008, "Nationale Kunstausstellung"
Autofriedhof, Kaufdorf CH

Comfort #4
PVC-foil, tubes, ventilator
4 tubes of 50 m each, 3 tubes of 60 m each, diameter 95 cm
2007, Villa du Parc, Annemasse F

Comfort #5
PE-foil, tubes, ventilator
6.7 × 4.8 × 6.8 m
2007, "The Memory of this Moment from the Distance of Years"
Former Schindler's Factory, Krakow PL

Shine #1
Aluminium anodized
diameter 70 cm, height 15 cm
2008, "more is more"
Galerie Loevenbruck, Paris F

226

2007
2006

Hotel Everland
Mobile one room hotel,
mixed media
12 × 4.5 × 4.5 m
2007, "Hotel Everland"
Palais de Tokyo, Paris F

Perfect #2
Plastic modules, lamps
20 × 10 × 5 m (1'500 elements)
2006, "5 Milliards d'années"
Palais de Tokyo, Paris F

Beautiful Wall #16
Wall painting
12 × 3.5 m
2006, "Experiments in Pop"
Zentrum Paul Klee, Bern CH

Hotel Everland
Mobile one room hotel,
mixed media
12 × 4.5 × 4.5 m
2006, "Hotel Everland" Galerie für
Zeitgenössische Kunst, Leipzig D

Beautiful Steps #1
Wood, lacquer, metal, wall painting
2.9 × 1.2 × 5.2 m
2007, Haus Nyffeler, Erstfeld CH

Surface #18, #17
Acrylic paint on glass
95 × 155 cm
2006

Beautiful Corner #4
Carpet
15 × 15 m
2006, "lumps and bumps"
Spiral/Wacoal Art Center, Tokyo JP

Perfect #4
Acrylic glass modules, lacquer
45 × 45 × 25 cm each
2006, "lumps and bumps"
Spiral/Wacoal Art Center, Tokyo JP

Loop #1
PVC-foil, tube, ventilator
2.1 × 0.8 m
2006, "Skulptur 06"
Mettlen Park, Muri CH

227

2006
2005
2004

Perfect #2
Plastic modules, lamps
20 × 2.7 m (488 elements)
2006, "Space Boomerang"
Swiss Institute, New York USA

Pocket Stadium *(2005)
Chrome steel, lacquer, aluminium, lamps
2.7 × 2.9 × 2.7 m
2006, "Trial Balloons" Musac, León ES

R16
Metal, lacquer
2 sculptures, each 10 m
2005, BKW Viktoriaplatz, Bern CH

sweet waste sweat
Wood, carpet
1.4 × 1.2 m
2006, "Read me"
Galerie Martin Krebs, Bern CH

Surface #16, #15, #14, #13
Acrylic paint on glass
49 × 40 cm
2005

Beautiful Walls #14
Wall painting
60 × 4.2 m
2005, "Malereiräume"
Helmhaus, Zürich CH

Belt Buckle
belt buckle with LED display
14 × 5 cm
2006, Multiple 1/5–5/5, Edition 5, Erstfeld CH
Martin-Gropius-Bau, Berlin D

Diving Platform
Steel, fiberglass, lacquer, diving board
4 × 1.8 × 13 m
2005, "Diving Platform"
Marks Blond Project, Bern CH

Perfect #2
Plastic modules, lamps variable
2004, "Perfect #2" Stage, Bern CH

Comfort #3
Polyurethane-foil, tubes, ventilator
3 cylinders, 2.2 × 5 m each
2005, "Focus Switzerland"
KBB, Barcelona ES

Spielfeld #2
Steel pontoon, paint, aluminium goals
6.2 × 19.6 m
2004, "Zoll/Douane"
Zollkanal Speicherstadt, Hamburg D

228

Beautiful Wall #13
Wall painting
9.2 × 2.5 m
2004, Haus Meile, Luzern CH

Beautiful Wall #12
Wall painting
6.8 × 4.3 m
2004, "Lasko"
CAN Centre d'Art, Neuchâtel CH

Lobby
Wood, paint, upholstery
14 × 5.5 m
2004, "Lobby" Kunsthalle,
St.Gallen CH

Beautiful Lounge #2
Wood, lacquer, carpet, wall painting
container 5.8 × 2.3 × 2.3 m
2003, "Kamikaze 2089"
Le Confort Moderne, Poitiers F
Collaboration with Sophie Dejode/
Bertrand Lacombe

Beautiful Entrance #5
Wood, paint
5 × 3.8 m
2003, "Transit.Chur", Chur CH

Perfect #1
Plastic modules
2.7 × 4.7 m
2003, "Floating Bowl"
Attitudes, Genève CH

Beautiful Lounge #1
Wood, paint, carpet, upholstery, lamps
8.4 × 8.4 × 3.5 m
2003, above Joburg Bar in Long
Street, Cape Town ZA

Beautiful Wall #10
Wall painting
17.25 × 3.5 m
2003, "Lee 3 Tau Ceti Central Armory
Show" Villa Arson, Nice F

2004
2003

Street Painting #2
Road marking paint
110 × 26 m
2003, Siedlung Hegianwandweg,
Zürich CH

Street Painting #1
Road marking paint
2 × 20 m
2003, "Môtiers 2003. Art en plein Air",
Môtiers CH

Sport Deluxe #1
Sweat jacket
S, M, L
2003, Multiple 1/5–5/5, Edition 5,
Erstfeld CH

229

2003
2002
2001

Beautiful Entrance #4
Wood, carpet
8 × 5.5 m
2003, "Mursollaici"
Centre Culturel Suisse, Paris F

Wow #5, #6
Wow #3, #4
Wow #1, #2
Acrylic paint on glass
49 × 40 cm
2003

Brunnen
Dyed concrete fountain
5.5 × 5 × 0.35 m
2002, Schaffhauserplatz,
Zürich CH

Kicker
Aluminium, wood, brass
115 × 370 × 250 cm
2002, "duell"
Galerie Urs Meile, Luzern CH

Clean #2
Styrofoam, fiberglass, epoxy, lacquer
variable, 15 modules
2002, "Tapetenwechsel"
Kunstmuseum, Solothurn CH

Hotel Everland
Mobile one room hotel,
mixed media
12 × 4.5 × 4.5 m
2002, "Hotel Everland"
Expo.02, Yverdon CH

Beautiful Wall #9
Wall painting
7 × 2.4 m
2002, "Cape Town Festival"
SA National Gallery, Cape Town ZA

Surface #8, #7, #5, #4
Acrylic paint on glass
116 × 94 cm
2001–2002

230

2001
2000

Dynamo Kyiv
Chalk drawing on the field
105 × 68 m
2001, "Dreamgames"
Dynamo Kiev Stadium, Kiev UKR

Shining Step #1
Styrofoam, wood, carpet, light
each 250 × 280 × 25 cm
2001, "70s versus 80s"
Museum Bellerive, Zürich CH

Infomobile *(1999)
Steel, wood, carpet
each 2.5 × 1.6 × 2.6 m
2001, "Collection"
migros museum für gegenwartskunst, Zürich CH

Beautiful Windows #1
Flat paint on glass
10 × 3.6 m
2001, "Window 002"
Kunstraum Walcheturm, Zürich CH

Beautiful Mezzanine #1
Wall painting
70 × 2.6 m
2001, "Transit, eine Navigation"
Kunstverein, Freiburg D

Beautiful Entrance #3
Wall painting
3 × 8 × 4 m
2001, Swiss Institute,
New York USA

Comfort #2 (2000)
PVC-foil, tubes, ventilator
10 elements, 2 × 3.5 × 1.5 m each
2001, "Collection Cahiers d'artistes"
CentrePasquArt, Biel-Bienne CH

Clean #1
Styrofoam, fiberglass, epoxy, lacquer
4 × 1.1 × 0.4 m
2000, "Door to Door"
Galeries d'Antiquaires, Nice F

Beautiful House #1
wall painting
33 × 2.15 m
2000, "L/B, Josh Blackwell"
Hot Coco Lab, Los Angeles USA

Module #1
Plywood, paint;
total 24 modules variable
2000, "Personal Brandscape"
migros museum für gegenwartskunst,
Zürich CH

Kraftraum
Wall painting, carpet, sound, plant,
mirror, workout units
4.3 × 4.4 × 2 m
2000, "Real Work"
Werkleitz-Biennale, Werkleitz D

231

2000
1999
1998

Beautiful Walls #7
Wall painting
2.8 × 12 × 3.9 m
2000, "Doppelgänger"
Shed im Eisenwerk, Frauenfeld CH

Childish Behavior #3
Motor, steel, styrofoam, fiberglass, epoxy, lacquer
40 × 80 × 110 cm
2000, "Transfert. 10th Swiss Sculpture Exhibition" Art in urban space, Biel-Bienne CH

Beautiful Walls #6
Wall painting
40 × 3 m
2000, "Painterly"
Contemporary Art Centre, Vilnius LIT

Module #2
Wood, carpet, water fountains, mushrooms
variable, installation with 40 modules
2000, "Positionen"
Haus für Kunst Uri, Altdorf CH

Wankdorf
Chalk drawing on the field
102 × 66 m
1999, "Kunst am Ball"
Wankdorf Stadion, Bern CH

Comfort #1
PVC-foil, tubes, ventilator
variable
1999, "Come in and find out vol.2"
Podewil, Berlin D

Race #2
slot car system
variable
1999, "Drive in"
Parking of the l'Archet 2 hospital, Nice F

Beautiful Wall #4, Race #3
Wall painting, slot car system
17 × 3.2 m, variable
1999, "999"
Ex-Troesch Building, Bellinzona CH

Module #1
Plywood, paint;
total 24 modules
variable
1999, "Au dernier cri"
Galerie Urs Meile, Luzern CH

Beautiful Corner #1
Carpet
4 × 8 × 4 m
1999, "SAT 2" migros museum für gegenwartskunst, Zürich CH

Screens #6
Screenprint wallpaper
variable
1998, "Déplacements"
95, Rue du Cherche-midi, Paris F

Das Kino
Mixed media,
Video Childish Behaviour #1 & #2
6 × 9 × 3.5 m
1998, "Freie Sicht aufs Mittelmeer"
Kunsthaus, Zürich CH

232

Beautiful Walls #3
Wall painting
10 × 12 × 3 m
1998, "L/B, Maxime Matray, Thomas Zoritchak"
La Station, Nice F

Sport #7
PVC-foil, tubes, ventilator
2.3 × 11 × 1 m
1998, "Spalinger, Fleury, Lang/Baumann"
CAN Centre d'Art, Neuchâtel CH

E15
Dyed concrete
one letter is about 80 × 70 × 15 cm
1996, Staldenkehr, Burgdorf CH

Beautiful Entrance #2
Wall painting
9 × 0.7 m
1998, "L/B, Maxime Matray, Thomas Zoritchak"
La Station, Nice F

Puppen #1
Mixed media
variable
1997, "Gallery by Night"
Studio Gallery, Budapest H
CentrePasquArt, Biel-Bienne CH

Lazy Bone #1
Mixed media
2.8 × 12 × 2.5 m
1997, "Nonchalance"
CentrePasquArt, Biel-Bienne CH

Inter will Roy
Wood, metal, paint
200 × 175 cm
1996, Kiosk, Bern CH

Beautiful Walls #1
Wall painting, 8 × 5 × 4 m
1998, "U.F.F. Opening"
U.F.F. Gallery, Budapest H

undo
PVC-foil, tubes, ventilator
2.8 × 10 × 1 m
1997, "You know my name"
Opera Paese, Roma I

Breathing Pillows
PE-mat, ventilators, electronic components
variable, 10 × 15 × 1 m
1995, De Fabriek, Eindhoven NL

1998
1997
1996
1995

233

* First shown in (YYYY)

Ein gemeinsames Hobby ist ein gutes Rezept für den Bestand einer Ehe

L/B

Sabina Lang *1972 and Daniel Baumann *1967 have been collaborating since the beginning of the 1990s. They live and work in Burgdorf, Switzerland.
www.langbaumann.com

Authors

Cathrin Langanke studied Art History and Multimedia in Karlsruhe. Since 2012 she has worked as an intern at the Wilhelm Hack Museum in Ludwigshafen.

Reinhard Spieler has been the Director of the Wilhelm Hack Museum in Ludwigshafen since 2007. He has curated numerous exhibitions of modern and contemporary art.

Akiko Miki is a senior curator at the Palais de Tokyo in Paris. She has also curated various exhibitions for Mori Art Museum in Tokyo, Barbican Art Gallery in London, Yokohama Triennale 2011 and others. She is also in charge of international artistic projects for the Benesse Art Site Naoshima, Japan.

Fabrice Stroun worked as an independent curator at institutions like MAMCO and Centre d'Art Contemporain in Geneva, Kunsthaus Glarus, Le Magasin Grenoble and Villa Medici in Rome. Stroun is co-founder of the artist-edition program "Hard Hat" in Geneva. Since 2012 he has been the Director of Kunsthalle Bern, Switzerland.

Sue Williamson is an internationally recognized artist based in Cape Town. Her work addresses the media, social issues, and aspects of contemporary history. She also writes and lectures about art, is the author of the books *Resistance Art in South Africa* (1989) and *South African Art Now* (2009), and the founding editor of www.artthrob.co.za, the leading website on contemporary art in South Africa.

Photographs

P. 2–3 Achim Kukulies
P. 10–15 Antonio Corcuera
P. 78–79 Otto Saxinger
P. 104–109 Robert Hofer

P. 222 Antonio Corcuera, Spiral #3 —
P. 223 Lorenz Ehrismann, Beautiful Wall #20 / Otto Saxinger, Comfort #10 —
P. 224 Robert Hofer, Street Painting #5 —
P. 226 Christian Helmle, Comfort #4 / François Charrière, Diving Platform —
P. 227 Katsuhiro Ichikawa, Perfect #4 —
P. 228 Musac, Pocket Stadium / David Aebi, R16 / FBM Studio, Beautiful Wall #14 / Oliver Heissner, Spielfeld #2 —
P. 229 Stefano Schröter, Beautiful Wall #13 / Sully Balmassière, Beautiful Wall #12 / Stefan Rohner, Lobby / Ralph Feiner, Beautiful Entrance #5 / Georg Rehsteiner, Perfect #1 / Mike Hall, Beautiful Lounge #1 / Oliver Imfeld, Beautiful Wall #10 / Hannes Henz, Street Painting #2 —
P. 230 David Aebi, Wow #1–6, Surface #4–8 / Claudia Leuenberger, Clean #2 / Caspar Martig, Hotel Everland —
P. 231 Peter Lüem, Infomobile —
P. 232 David Aebi, Childish Behavior #3, Module #2 / Jean-Pierre Grüter, Module #1 / FBM Studio, Das Kino —
P. 233 Oliver Imfeld, Beautiful Walls #3, Beautiful Entrance #2 / David Aebi, Sport #7, Lazy Bone #1, undo, Inter will Roy / Peter Cox, Breathing Pillows

All others by L/B

Translated texts

For the German versions of the texts please visit: http://langbaumann.com/text

This book has been published on the occasion of the exhibition
"Struktur und Zufall",
Wilhelm Hack Museum, Ludwigshafen D
16.3.–12.5. 2013

Lang/Baumann
More is More

Edited by Sabina Lang/Daniel Baumann
& Editions Loevenbruck, Paris

Text: Cathrin Langanke/Reinhard Spieler, Akiko Miki, Fabrice Stroun, Sue Williamson
Proofreading: Louise Stein
Translations: Dieter Kuhn P. 222–233 Catherine Schelbert P. 167–170
Design: NORM, Zürich
Typeface: Antique

Printing: DZA Druckerei zu Altenburg GmbH, Germany
Made in Germany
Published by Gestalten, Berlin 2013
ISBN 978-3-89955-481-6

© Die Gestalten Verlag GmbH & Co. KG, Berlin 2013

All rights reserved. No part of this publication may be reproduced or transmitted in any form or by any means, electronic or mechanical, including photocopy or any storage and retrieval system, without permission in writing from the publisher.

For more information, please visit www.gestalten.com.

Bibliographic information published by the Deutsche Nationalbibliothek. The Deutsche Nationalbibliothek lists this publication in the Deutsche Nationalbibliografie; detailed bibliographic data are available online at http://dnb.d-nb.de.

gestalten